LIGHTSHIP
JIM BURNS

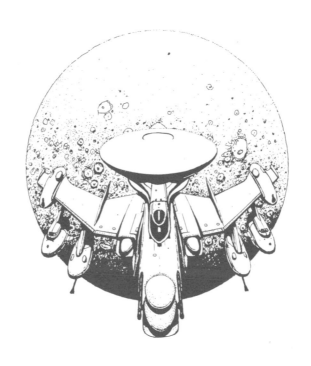

Text CHRIS EVANS

Produced by MARTYN DEAN

A Dragon's World Ltd Imprint

Dragon's World Ltd
High Street
Limpsfield
Surrey RH8 0DY
Great Britain

Edited, Designed & Produced by Martyn Dean

**Dedicated to
Sue, Elinor, Megan and Gwen
for being there.**

Special Thanks to Alison for her patience
and to mum and dad.

Hardback: ISBN 1 85028 010 X
Limpback: ISBN 1 85028 011 8

Printed in Singapore.

CONTENTS

Planet Story – War Wolves 1979, Pierrot Publishing

PREFACE
ROBERT SILVERBERG

I spent decades searching for the right artist — the one who could lay his hands on one of my books for ten minutes and come away with such a complete understanding of the texture and imagery and *feel* of the book that he could render a perfect pictorial representation of it. Picasso didn't work out: he kept trying to rewrite the books himself, and I couldn't have that. Miro was shot down by the art director in New York: too cute for paperback covers, they said. Matisse might have been suitable, but his agent gave us all a hard time and we never could cut a deal.

And then Jim Burns turned up.

It was in 1980, I think. I had written a book called *Lord Valentine's Castle*, with a huge cast of human and other beings and a thirty-mile-high mountain in it. Having been through the usual round of hardcover publication on both sides of the Atlantic it passed on to paperback; and one day the American paperback people sent me a proof of the cover painting they proposed to use. It was a wraparound affair with Valentine and his juggling team of alien 'critters' on one side and the vast castle-topped mountain on the other. Elegantly painted, too; but what struck me most forcefully was the expression on the face of Valentine, a wondrously subtle mix of innocence and craftiness, of gentleness and strength: Valentine to the life.

"It's terrific," I said. "Who painted it?"

"Englishman. Name of Jim Burns."

"Never heard of him," I said.

"You haven't? That's odd. He's already painted covers for a bunch of your books in England."

He had? Well, I must not have been paying close attention. Those other books had all come out at a time when, in a fit of general disgruntlement, I had wound up my writing career forever and ever and had gone off to play in my garden. During those years my interest in what happened to my books began and ended with the royalty statements. But now I dug out the ones that this Jim Burns had supposedly illustrated, and I was startled by their intricacy, their beauty, their aptness. I loved them. (All but one, which was so diabolically horrifying that I hated to look at it at all. It made my flesh creep, and it still does, and I still hate it. Perhaps Jim didn't paint that one, although I suspect, by the feel of the craftsmanship, that he did. He may ply me with brown ale, all night, but he'll never learn from me which one it is).

After seeing the *Valentine* cover, of course, I started looking for his work, and saw plenty of it around. All of it splendid, though somehow it seemed to me that the paintings he had done for my books were a cut above the rest — as if there were something in my books that reached him in a special way. "Forsooth", I said, there's certainly something in his paintings that reaches *me* in a special way. I suggested to my American paperback publisher that it might be a good idea to use Jim Burns on the covers of a forthcoming batch of reissues of my best earlier novels. "We've already arranged for that," I was told. Indeed they had; and over the months ahead came eight or ten splendiferous Jim Burns covers for *The Book of Skulls* and *Dying Inside* and *Tower of Glass* and all the rest. And when, somewhat to my surprise, *Lord Valentine's Castle* was followed by the other two volumes of what is now known as the *Majipoor Trilogy*, Burns did those also — for the American paperbacks and (with different paintings) for the British hardcovers.

So it's just as well that Picasso didn't work out, that Miro was too cute, and that Matisse's agent gave us a tough time. By waiting a little longer I wound up with Jim Burns, who by some mysterious process of psychic tuning seems to have become the artist I was meant to have all along. His work satisfies me on every level, from the glistening surfaces down into the mysterious revelatory depths. I suppose the ones he does for the Silverberg titles are closer to my heart than any of the others — you can understand that, can't you? — but I've been keeping an eye out for his other work over the past few years, and none of it has been less than splendid. As the book you are now holding amply demonstrates, a Jim Burns cover painting is not only visually delightful, a work of sleek and shining art, but it's generally also keenly revelatory of character, and marvellously inventive in a science-fictional way.

That last is the best part of all, I think. The art schools release a flood of technically proficient new graduates every year, but it's a rare one who has that extraordinary science-fictional manner of seeing the world which makes for a great s-f artist — a Hubert Rogers, a Kelly Freas, an Ed Emshwiller, a Jack Schoenherr, a Jim Burns. It's been a joy and a privilege to have so many of Jim's fine paintings illuminating my books, and it's a pleasure now to repay that in some very small measure by slipping a few words in praise of him into this book of his.

Robert Silverberg © 1986

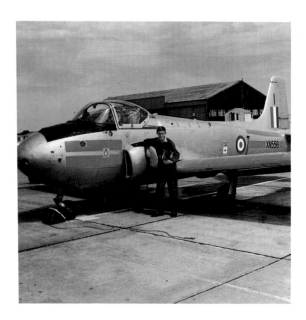

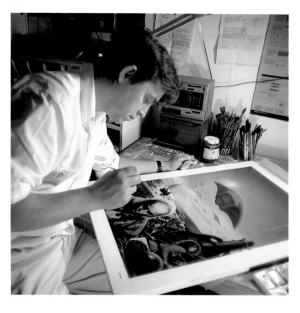

Jim Burns in former incarnation, shortly after first solo jet flight.

Jim Burns in his studio finishing the painting on page 113.

LIGHTSHIP INTRODUCTION

We live in an age so well-documented that it is often difficult to escape both the mundane domestic facts of life and the all-too-real dramas of the world at large.

Science-fiction and fantasy art appeals to people by presenting images of realities which are different from those we know. It shows us exotic futures, alternative presents, pasts which have never existed in history books: it offers an avenue of escape — in the blink of an eye we can be standing on an alien planet, confronting mythical creatures, or flung forward into the far distant future.

Yet the appeal of such art is not merely escapist. Often it delights by the sheer exuberance of its invention or rewards by its intriguing hints of what might be. It offers new landscapes and lifestyles, suggesting possibilities which may provoke us into questioning our own assumptions and customs. Its visions may be inspirational or cautionary, but at its best it has in common with its sister literature a tendency to make us think. This book aims to highlight some of its major motifs through the work of a talented artist whose versatility has enabled

him to produce illustrations over a wide range of areas within the field.

Much of today's speculative art draws its visual vocabulary from science-fiction and fantasy books — a branch of literature which has only existed as a distinct category for about sixty years. It was poorly paid writers working for cheap magazines (the so-called "pulps") in the United States during the 1930s and '40s who were mainly responsible for mapping out the territory over which today's science-fiction and fantasy artists range. The fiction these writers produced, however, was seldom evocative visually. Prose was plain and workmanlike, descriptive details often pared to a minimum as the writers concentrated on slam-bang action or mind-boggling ideas.

It was left to the artists who produced the magazine covers and interior illustrations to convey the visual exoticism inherent in the material. It was they who actually showed us the future in all its garish and improbable detail — a future filled with hulking robots, aircars, spaceships and aliens of every description. It was they who took us back into the quasi-historical past or to other realms where magic and monsters abounded. The artists had a symbiotic relationship with the fiction the writers produced, and it continues down to this very day.

Jim Burns became a commercial illustrator after leaving art college in 1972. Since then he's produced over three hundred illustrations, most of them book-cover art for writers such as Ray Bradbury, Arthur C. Clarke, Robert Silverberg, and many others. When considering the illustrations in this present volume, it's important to bear in mind that most of them are works inspired by specific books or stories, often composed according to publishers' specifications and the inevitable constraints of book formats.

One thing which distinguishes Burns from many other artists working in the same field is the range and thematic diversity of his illustrations. He's produced covers for all sorts of books, as well as drafting designs for cars and computer software packaging. But his favourite kind of

art lies in the science-fiction field.

As a student in art college, Burns worked mostly in coloured pencils, and for his early cover art he used pencils and watercolours. He was taken on by the Young Artists agency in London before he left college, but when he began free-lancing he soon realized that his art-school training had not equipped him for the demands of a commercial market. "I kid you not, I learnt more about the business of being a freelance illustrator in six months of work than all of the previous four years at art college.

"For the first few years I worked chiefly in gouache — opaque water colour, which seemed to be the chosen medium of most successful illustrators. But I found that the painted surface was vulnerable to splashes or even a sharp tap which could cause half the picture to fall to the floor in a cloud of dust. Gouache also inclined me towards a rather stilted, clinical approach, so eventually I bought a whole heap of quality oil paints.

"After a couple of false starts I eventually discovered the sheer *superiority* of the medium. The beauty and richness of oil-colour remains unsurpassed by any other medium, and I found that oils would go through an airbrush without any problems as long as the paint was conscientiously thinned to the appropriate consistency. In my own eyes, my work improved enormously over the next year or two after taking up oils. I found myself experimenting with texture and random effects generated by dripping a variety of liquids on to airbrushed surfaces in various stages of drying. Most importantly of all, I discovered that gloriously transparent glazes could be laid down through the airbrush even when the paint was still wet. This is something utterly impossible with ordinary brushes.

In 1980 Burns spent ten weeks in Los Angeles, working on designs for the film *Blade Runner*, which required him to produce quick-fire ideas on paper. This finally led him to move from oils to faster-drying acrylic paints. "Acrylic paints are the ones that most closely resemble oils, and I was keen not to throw out all the advantages I had acquired in several years of experimenting with oils. It

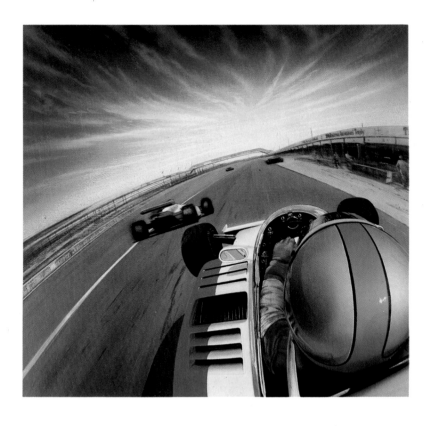

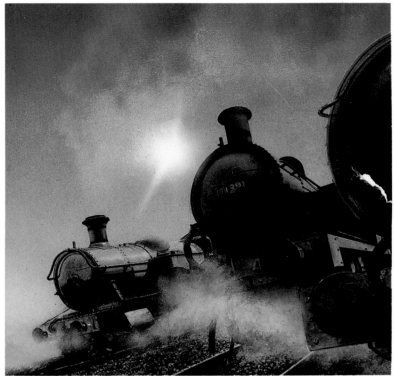

Fantasy Games 1982, Psion Software

wasn't long before I twigged that of all the major media, acrylics were in fact the *easiest* to use."

Since 1980 the majority of Burns's pictures have been for U.S. publishers. "I'm notoriously slow, and I would find it difficult to make much of a living if I depended solely on British commissions which pay perhaps a fifth of their American counterparts. But on the whole I get more of a free hand in deciding what goes on the covers of British books. U.S. art editors are more inclined to provide me with a brief — sometimes just an outline but more frequently a very specific description of the image they'd like to see. This can impose some pretty stultifying disciplines on me, though I prefer to regard this as a challenge rather than a pain. But I do my best work when I'm given a free hand."

Burns reads everything he illustrates, and his sympathy for science fiction as a literary form stands him in good stead. "I let the imagination of the author create the characters and overall aspect of a scene. I apply my imagination to the detail and the ambience. Ultimately

Train Race 1982, ICL Software

Racetrack 1982, ICL Software

The Ceremonies colour studies 1984, Bantam Books, New York

one arrives at an image which has a degree of conviction about it — a potent reality emerging from a scene which has nothing at all to do with reality."

What's notable about his pictures as a whole is that they conform to no consistent pattern or preoccupation. Occasionally favourite images do recur — such as vehicles in electric blues — but in general he's keen to avoid an instantly recognizable style with a particular stock-in-trade of imagery. Using both paintbrushes and airbrushes, he works on hardboard sized with a white acrylic primer, using latex fluid to mask off areas of a picture when necessary. He sprays on layer after thin layer of colour with the airbrush, thereby achieving a clarity and vibrancy of colour often counterpointed elsewhere in the illustration by paler, subtler shades and indistinct forms.

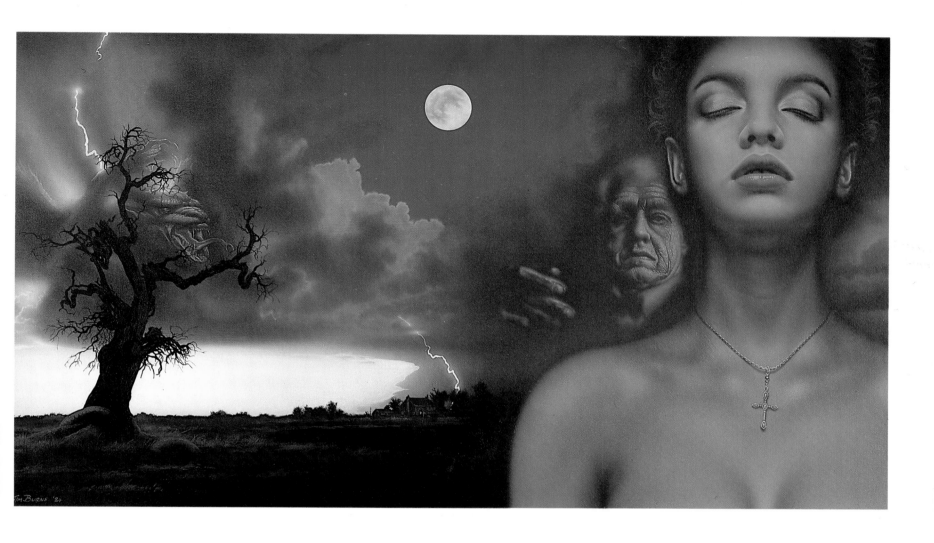

The Ceremonies 1985, Bantam Books, New York

In fact, much of his best work achieves its effects through a marriage of contrasts, though not simply colour contrasts. Sleek, bright hulls are surrounded by hazy cityscapes; glossy plastics are juxtaposed with mottled stone or pitted bone; humans sit in perfect ease with androids or weird alien species; figures dominate the foregrounds of pictures with vast horizons and swathes of sky.

Burns's illustrations usually have a human dimension and a narrative feel — a sense that they're a still from an ongoing story. "People seem to like the human element in my pictures. I like the notion that they are a bit like windows — the figures in them catch you looking at them." The narrative aspect of his work reflects the literature which he illustrates, science-fiction and fantasy being storytelling modes of fiction above all.

"For me the portrayal of the human figure has always been the most appallingly difficult task. I have no natural talent at all for this. If I try to create a figure totally out of my imagination, then the result is usually completely unacceptable. The great masters portrayed the human body so well by virtue of an extremely thorough study of anatomy, but I never got any of that. Art college training in the late '60s and early '70s provided graphics and illustration students with some life-class experience, but it was of a nominal and not very seious variety."

So Burns uses what he calls the "Doctored, Found Reference Method", which involves accumulating a huge file of photographic material from all sorts of sources such as Sunday colour supplements. He then uses different bits and pieces from these sources to create the effects he wants, backed up with the occasional photographic

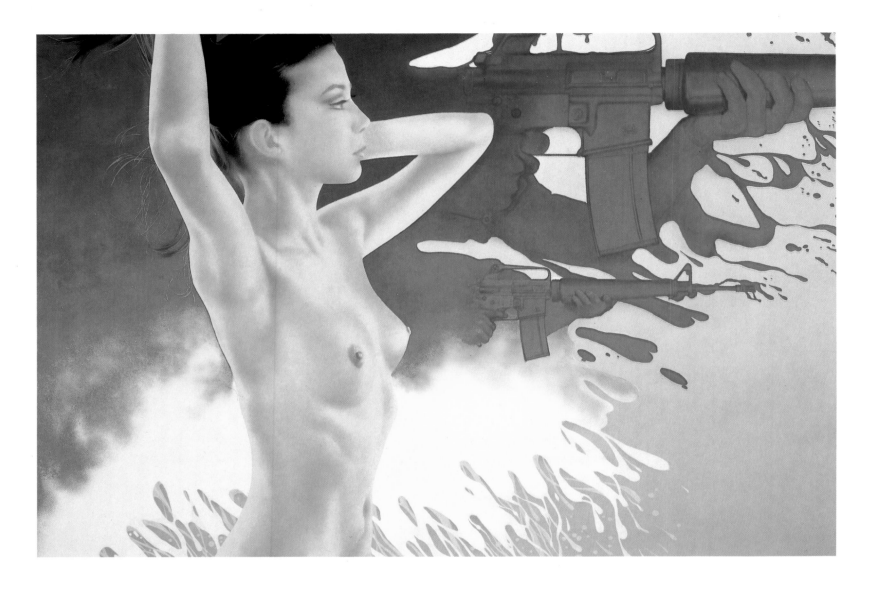

The Bang, Bang, Bang 1977, Men Only

session if something very specific is required. "With experience the material can be pushed and pulled in such a way as to lose much of its original identity but still retain sufficient 'photo-realism' to convince. Curious small anomalies sometimes creep in which can often lend a desirable air of distortion to a figure, so long as the basic anatomical truths are not pushed aside."

Burns collects books and magazines and any illustrated material which might have potential as a source of imagery, filing them under such categories as "Exotic Hardware", "Motor Cars", "Architecture", and so on. Art Nouveau designs are a particular favourite, and they help create one of the distinctive features of his art which he describes as "baroque technology" — spacecraft in which curves, ornamentation and textured surfaces all feature strongly.

Among his many illustrative interests, Burns is fascinated by the idea of depicting aliens and alien technologies, of trying to suggest in his pictures new materials and new forms. In essence his aim is to create

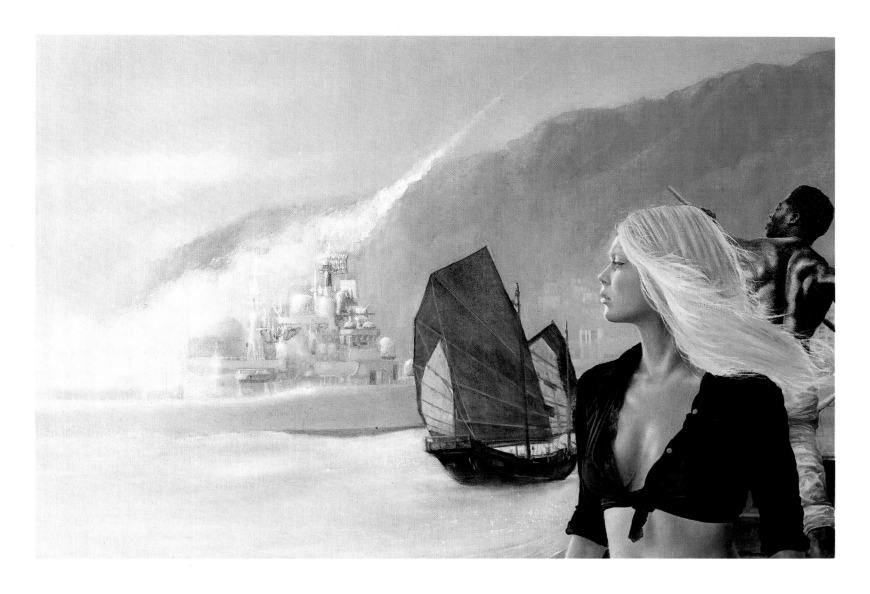

The Bright Cantonese 1976, Coronet Books

visually that "sense of wonder" which the best written science-fiction evokes — a feeling of awe and excitement that one is encountering either something quite unfamiliar, or familiar things combined in new ways.

The chapters which follow will explore images in science-fiction and fantasy art with particular reference to Jim Burns's work. The illustrations have been edited into categories, so that works of related subject, ambience or interesting juxtaposition are grouped together. It's worth repeating that most were commissioned for specific books and that many are eclectic pieces which do not readily conform to any specific classification. And the categories themselves are more flags of convenience than strictly defined territories. Speculative art, like speculative literature, is a continuum in which many kinds of wonders occur together. And in Jim Burns's art you'll find wonders aplenty, brought vividly to life.

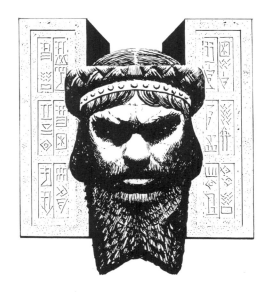

MEN LIKE GODS

History is in the eye of the beholder, and our visions of the past are always conditioned by the present in which we live. The urge to romanticize or make more dramatic earlier periods is nothing new. Geoffrey of Monmouth, writing in the twelfth century, elaborated a whole mythos of Arthurian legend under the guise of a *History of the Kings of Britain*. In some respects the past is just as fraught with possibilities as the future since we can never be entirely sure exactly how it was.

"There are three versions here of *Gilgamesh the King*, based on Robert Silverberg's adaptation of the ancient Sumerican epic. It's not difficult to find extraordinarily close connections between much science-fiction and this kind of semi-mythologized stuff. Gilgamesh actually existed, but time and the re-telling of the legend have endowed him with more and more superhuman attributes. The pleasure in painting a character like Gilgamesh is that his remoteness in time — 2500 BC — renders him as alien to us as the unimaginable peoples of 4500 years into our future. There is precisely the same kind of appeal to the imagination in painting, say, the ziggurat in the background of these pictures as in trying to portray *Alien tenement block, Deneb IV*. They are both equally strange and equally unknowable."

Fantasy art which looks to the past makes its imagined times more grand, heroic and magical so that it tends to endow those times with mythic qualities. Kings, queens, warriors and wizards are usually splendid specimens of humanity, whether they are hacking heads off, grappling with demons or bound up in chains. The most popular figures are those of the warrior and the outcast, often based on the prototypes of Robert E. Howard's "Conan"

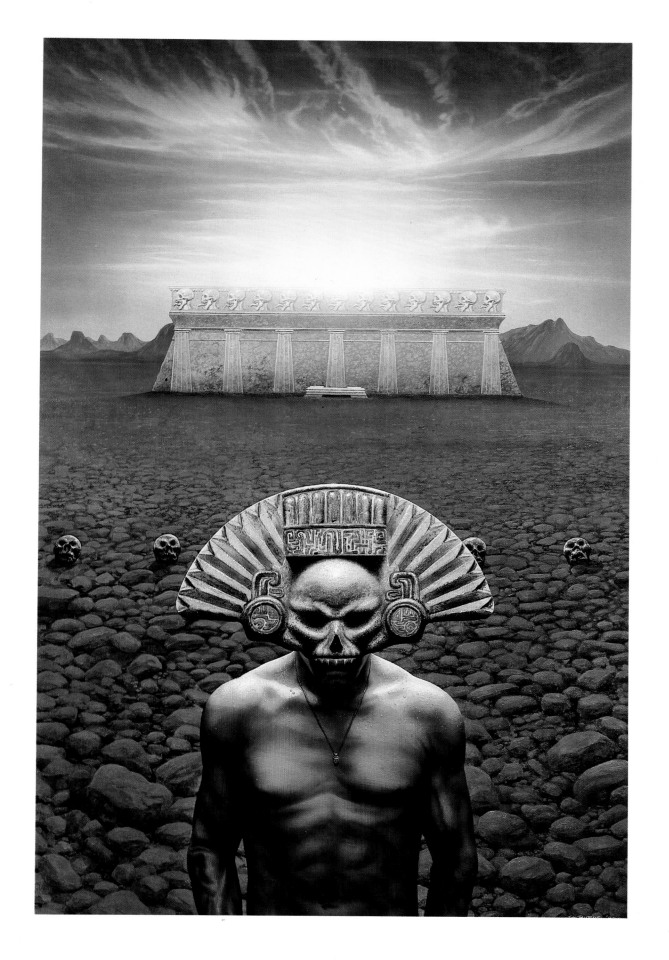

The Book of Skulls 1982, Bantam Books, New York

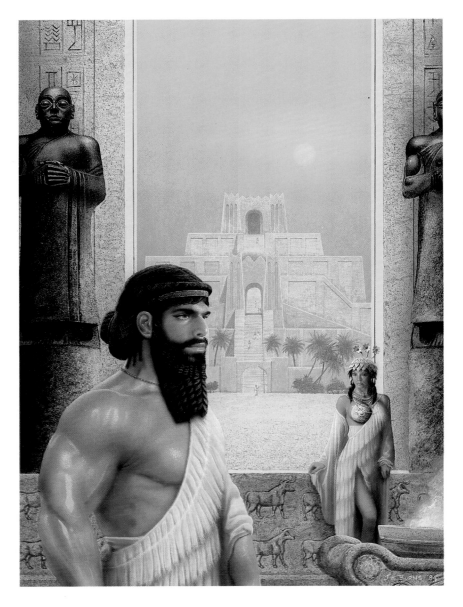

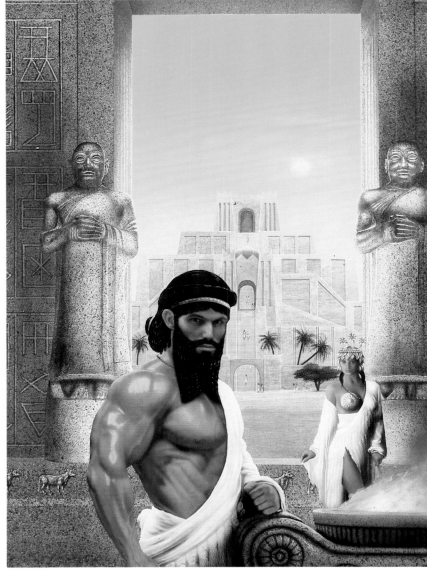

Gilgamesh the King (1) 1984, Bantam Books, New York

Gilgamesh the King (2) 1985, Bantam Books, New York

and Edgar Rice Burroughs's "Tarzan".

Conan, created in the 1930s, is the archetypal muscle-bound hero, strong of limb but somewhat lacking in the intellectual and social graces. In a long series of books, Howard has his hero hacking his way across an ancient landscape only loosely based on history and filled with sorcerous dangers. Tarzan inhabits more modern times, but he nevertheless exists in an African jungle holding not only spurious Asian tigers but also a host of creatures and peoples who owe as much to fantasy as reality.

The essential attributes of Conanesque warriors are that they be magnificently built, with a wild, savage,

pagan look to them. This sort of fantasy is written and illustrated overwhelmingly by men, and the heroes exemplify the raw masculine qualities of courage, strength and physical power. No doubt their popularity is connected with the fact that these are precisely the qualities which can seldom be expressd in their purest form in the present day. Civilization, and particularly modern civilization, tends to demand of us that we quell or sublimate such primal instincts. But in heroic barbarians they are given full rein.

Tarzan has spawned a different kind of fantasy hero who tends to be more civilized but is isolated from

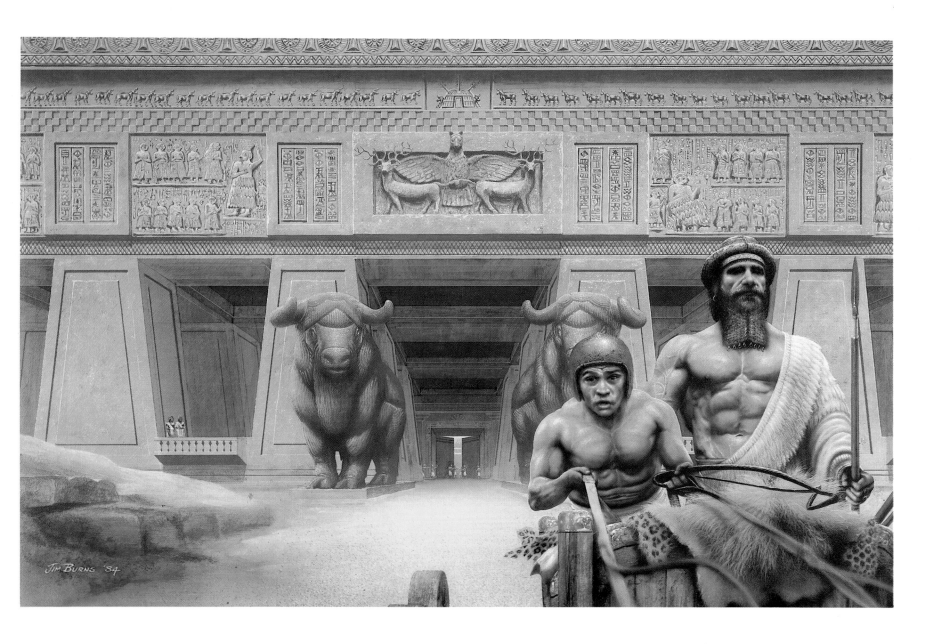

Gilgamesh the King 1984, Gollancz

ordinary society in some way. A modern and sophisticated variant is Michael Moorcock's Elric of Melniboné, an albino prince shunned by his own people who carries a sentient black sword called Stormbringer. The outcast-as-hero need not necessarily be built like Charles Atlas or Arnold Schwarzenegger; what's more important is that he has a haunted, often doomed air. The appeal here is probably to those of us who feel we're misunderstood, and which of us hasn't felt that way at some time or another?

Women in these male-dominated stories are frequently portrayed either as victims or villains. As victims they may be mere appendages, adoringly in thrall of the heroes' power or more obviously requiring rescue by them. As villains they are often seen as sirens, luring noble-browed warriors into danger using all their feminine wiles and often a good dose of sorcery into the bargain. The sexual metaphor here is so striking as to scarcely need stressing. The female principle is identified with the non-rational, mystic and therefore treacherous powers of the mind; it threatens to undermine the rule of man in general. Further sexual symbols such as writhing snakes and twisted trees also figure strongly in such illustrations, while landscapes tend to be invaded by mist and darkness,

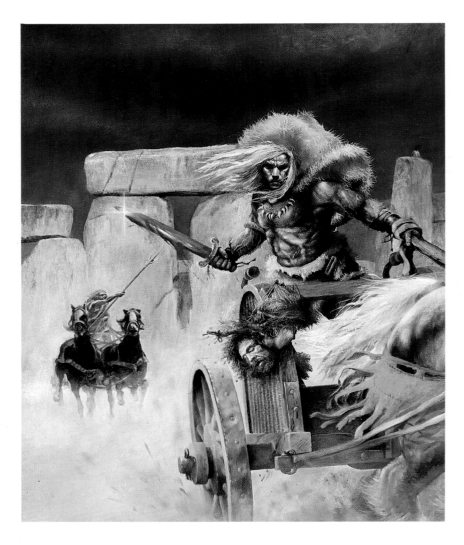

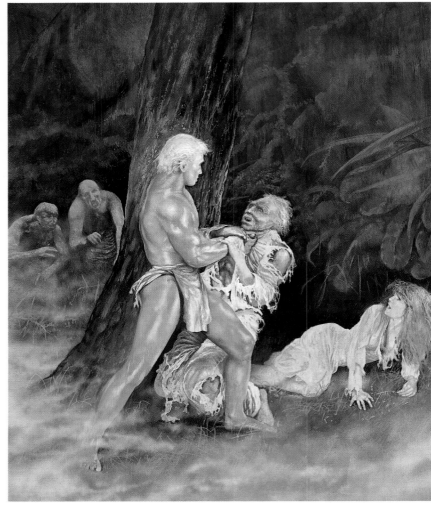

The Power of the Serpent 1976, Corgi Books

The Monster Men 1976, Tandem Books

further conveying that sense of rationality swamped by seductive passions.

Fantasy art of this nature is thus a fertile breeding ground for the instinctive expression of our deepest desires and fears. But to see it as just that is to ignore sound practical and aesthetic reasons which often consciously influence the artists' choice of imagery. Jim Burns feels that this tendency sometimes leads people to misunderstand his intentions:

"The kinds of pictures assembled under this chapter reveal a specific interest I've discovered in myself over the years — the portrayal of human physicality, both male and female. The human body is really an infinitely variable landscape, and male muscularity or female pulchritude provide me as a painter with endless possibilities. It's also one area of contention I sometimes encounter. I like occasionally to push the shape and form of the human body towards exaggeration, and if that body is female I've found that sometimes people take genuine offence. I get accused of 'sexist depiction of the female form'. I can only lament the lack of a sense of humour in some people and would add that if you go through my pictures you'll find women playing the heroic role as often as men — if not more often."

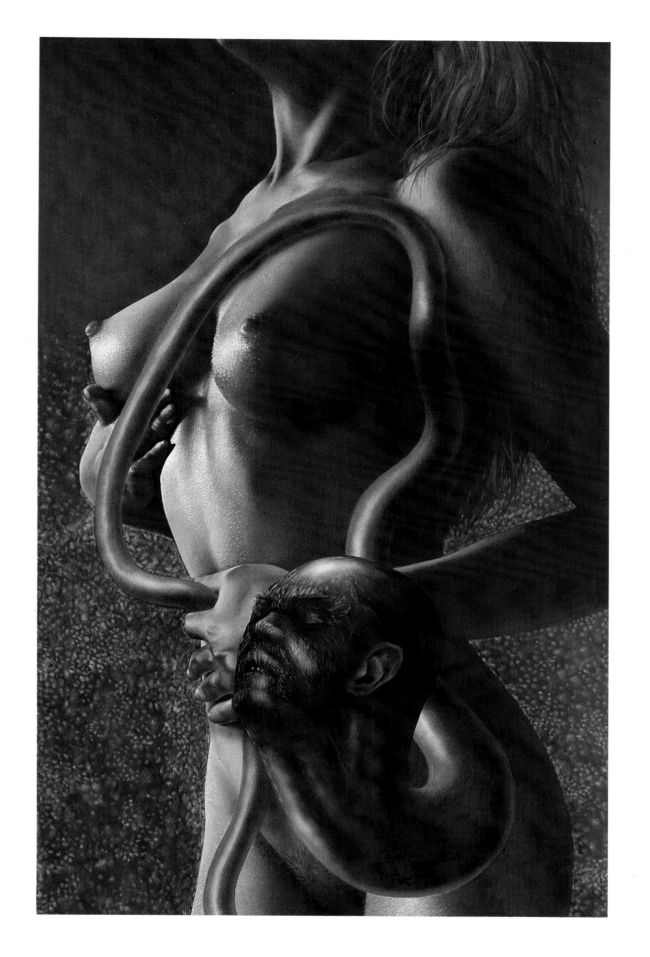

Blown 1975, Quartet Books

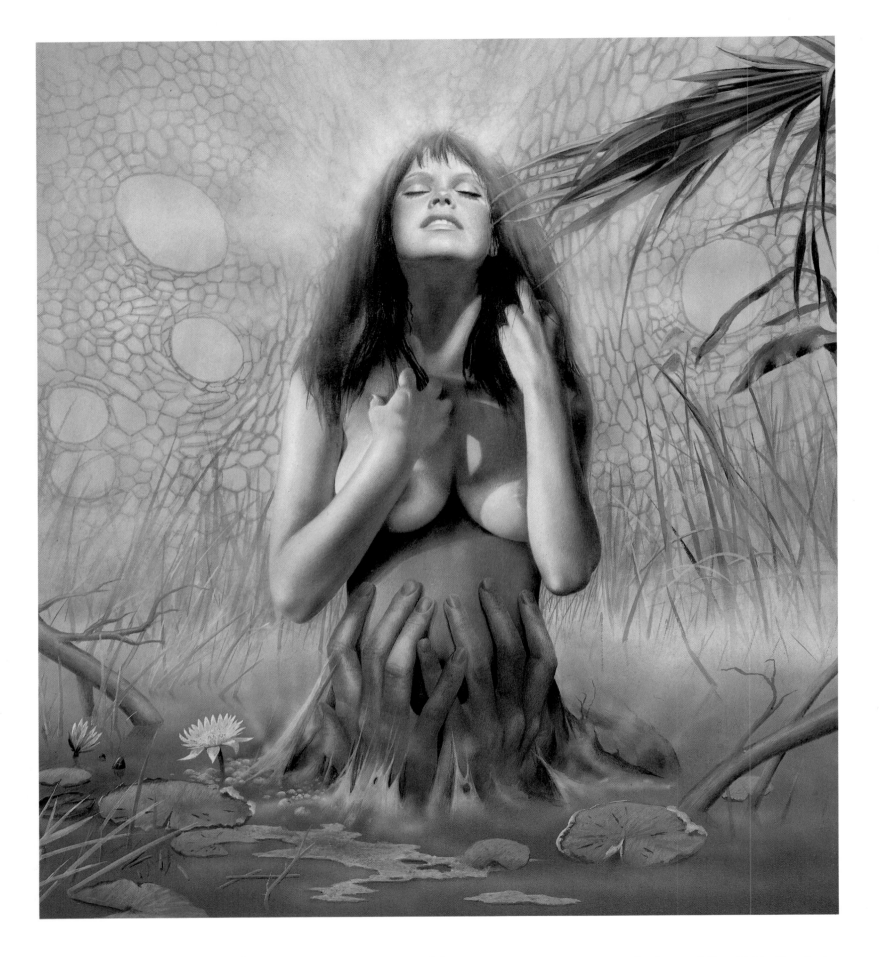

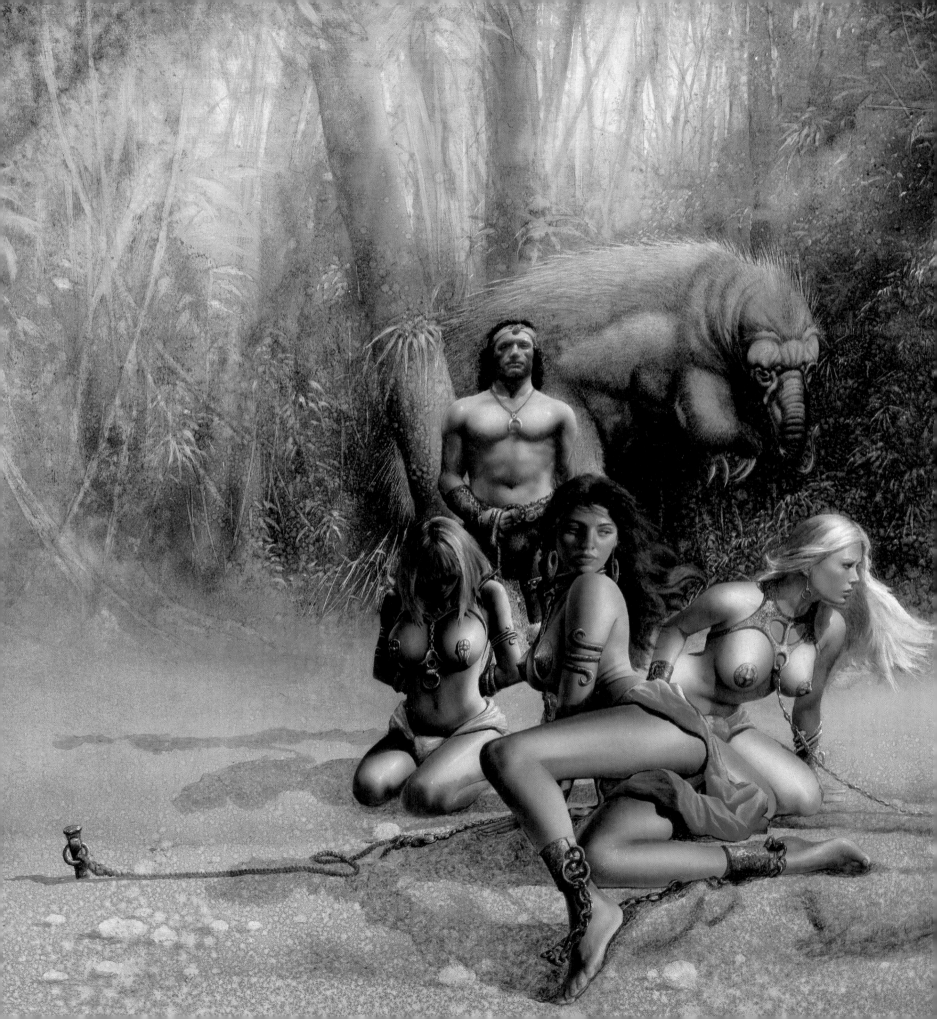

IMAGE OF
THE BEAST

Tales of fabulous beasts have haunted the human race ever since the dawn of civilization. All cultures throughout history have had their stories of legendary creatures, and today's Yeti and Bigfoot are in an ancient tradition. In recent years serious attempts have also been made to imagine how beasts might look in the future or on other planets. A zoologist, Dougal Dixon, has even produced an illustrated book, *After Man*, which applies evolutionary principles to show how the fauna of Earth might evolve in the next million years or so.

Beasts are ambivalent symbols. They may be cosy and domestic, such as cats and chickens, or repulsive and threatening, such as scorpions and sharks. The best depictions of animals in science-fiction and fantasy art often combine both the familiarity and the fear which we sometimes feel in the presence of a guard dog, a pet snake, a spider crawling up the bedroom wall.

The early magazine artists tended to concentrate on the grotesque and ghastly aspects of creatures in their illustrations. Giant-sized ants and frogs were common, and they were usually employed for their shock value, to contrast with the noble humans whom they threatened. A few artists did show a companionship between ordinary people and strange animals, but in general the

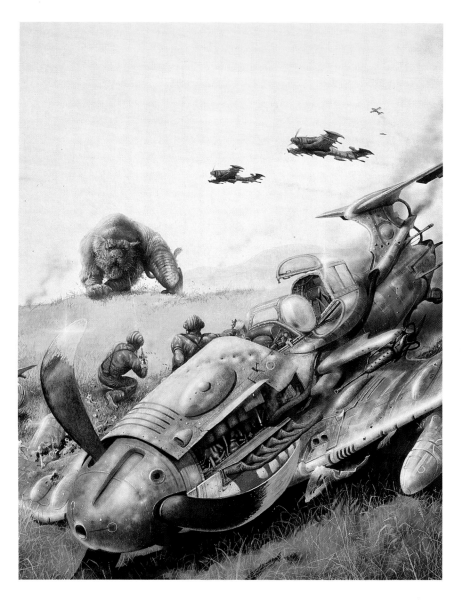

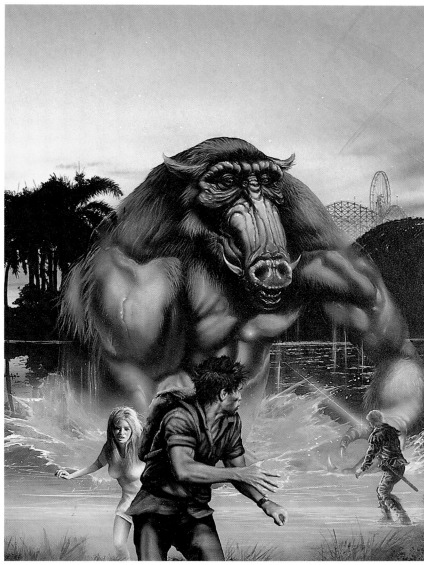

Beyond the Farthest Star 1976, Tandem Books

Dream Park 1982, Ace Books, New York

beasts were to be feared.

As well as exaggerated versions of living animals, prehistoric creatures have also been popular with artists. The more heroic forms of fantasy illustration frequently show muscle-bound humans doing battle with sabre-toothed tigers, mammoths and dinosaurs of every description. These creatures help heighten the sense of primitiveness and savagery of a world, reminding us of the fragility of human lives in earlier times when strength and stamina mattered most. Used in obviously science-fictional settings, they hint at time-travel or other worlds where evolution has taken a slightly different course; they help highlight the contrast between technologized peoples and nature red in tooth and claw.

Beasts are primal images which tap deep into our psyches, and mythic creatures such as unicorns and griffons continue to populate the pages of fantasy novels. Many are modernized versions of heraldic animals, so demonstrating the hold they have retained on the human imagination over many centuries. And perhaps the most popular fantasy creature of all is the dragon.

The dragon is a universal symbol which can be found in most cultures of the world, whether primitive, classical or oriental. In many respects it's the archetypal adversary,

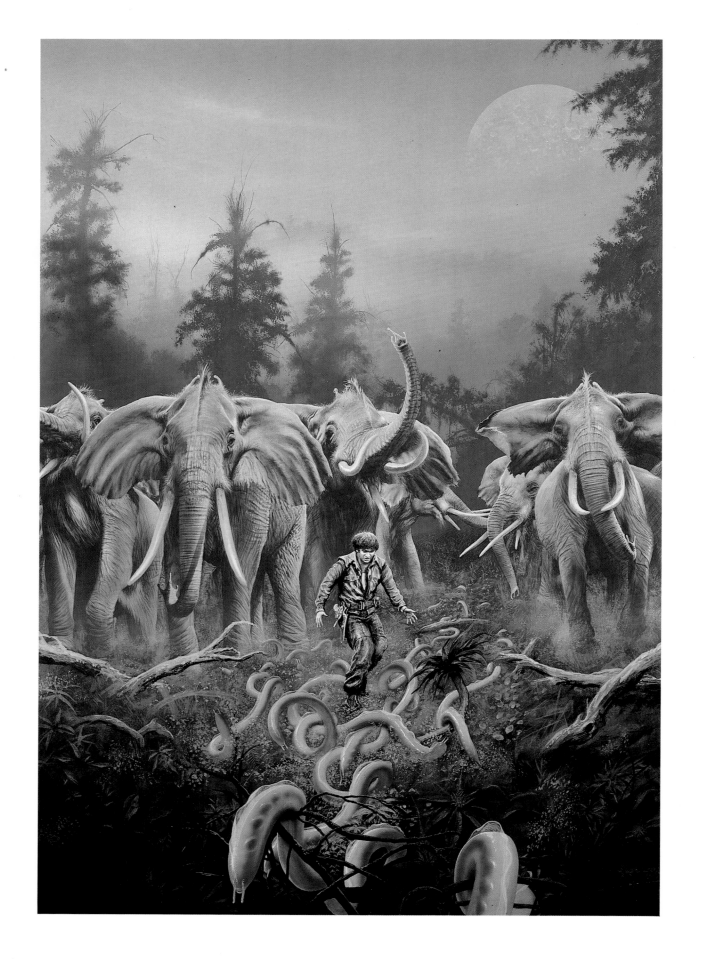

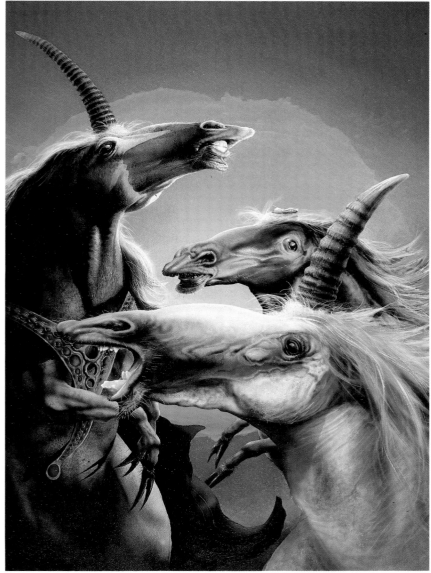

Jem 1979, Panther Books

The Best of Arthur C Clarke 1937-1955, 1981, Sphere Books

though an interesting modern tendency is to give it a scientific rationale and make it more friendly — both ways of domesticating the beast. But whether as friend or foe, it's usually portrayed with a St George figure — a human who tames it either through battle or friendship.

Heraldic animals are often chimeras — combinations of familiar creatures. In creating beasts of other worlds and times, writers and artists commonly blend elements of different creatures, and often their names alone can be made to suggest their appearances — the tigerdog, say, or the mantis-fish, or even the rhinocerhorse. The scope for invention here is enormous and has perhaps been underexploited by writers and artists, most of whom tend to stick to a limited range of prototypes for their hybrids.

"For me the richness of the Earth's fauna is of enormous interest," says Jim Burns. "The following of

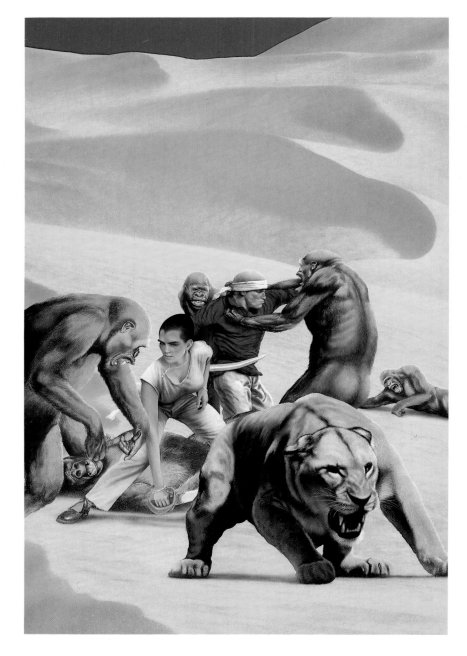

Return to Eddarta 1984, Bantam Books, New York

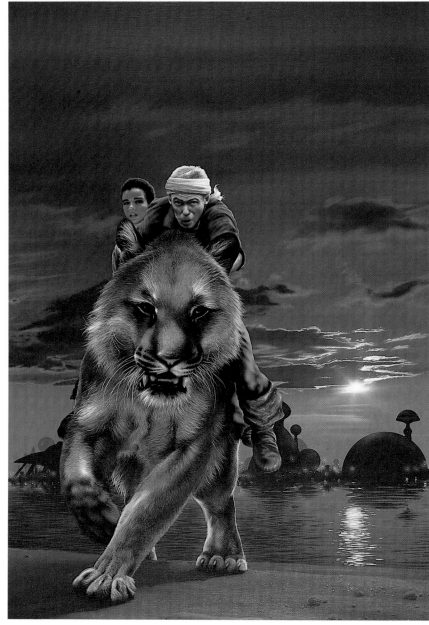

The Bronze of Eddarta 1983, Bantam Books, New York

natural history in some form as a career came a close third after the RAF and illustration. I maintain an abiding interest in natural history illustration, and I'm often able to draw on this knowledge in depicting alien animal forms. Sometimes the author describes creatures which differ only slightly from well known species — such as the horned elephants in Robert Silverberg's *Downward to the Earth* and the almost sabre-toothed cats of *The Gandalara*

Cycle by Randall Garrett and Vicki Ann Heydron. One can run through a whole gamut of types from the unicorn-derived beings on the cover of *The Best of Arthur C. Clarke 1937-1955* to the multi-footed, arboreal, gun-toting apparition in Frederik Pohl's *Jem*. It always gives me pleasure to try and portray as closely as possible the creature the writer had in his mind's eye and above all else to make them seem alive and real."

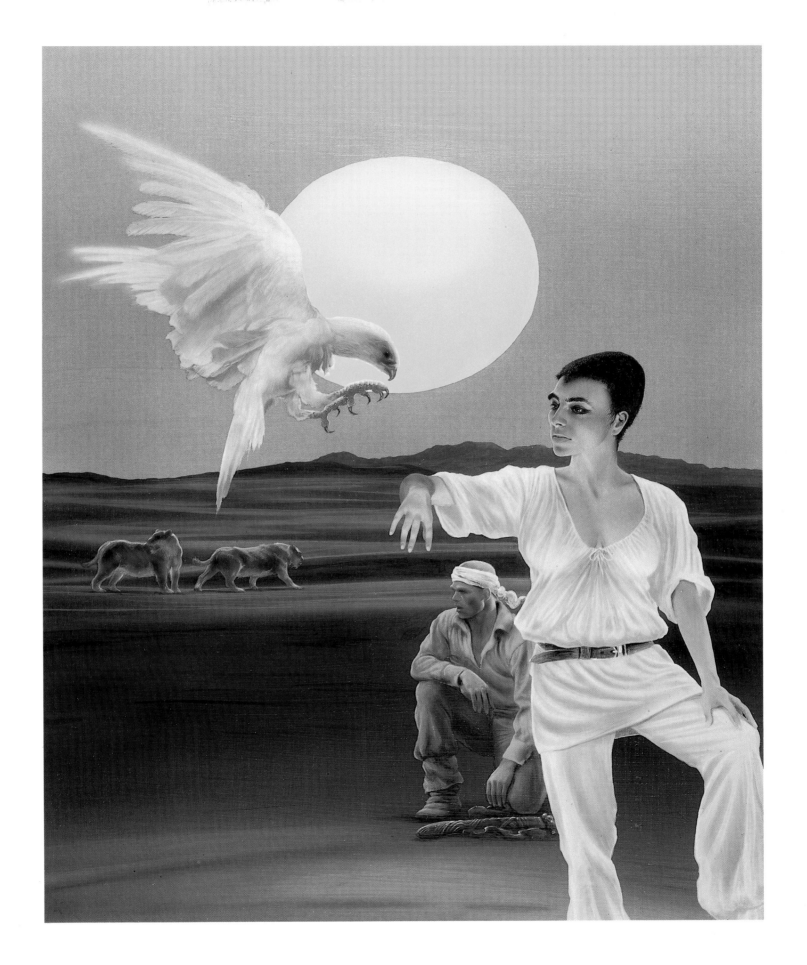

29 *Well of Darkness 1983, Bantam Books, New York*

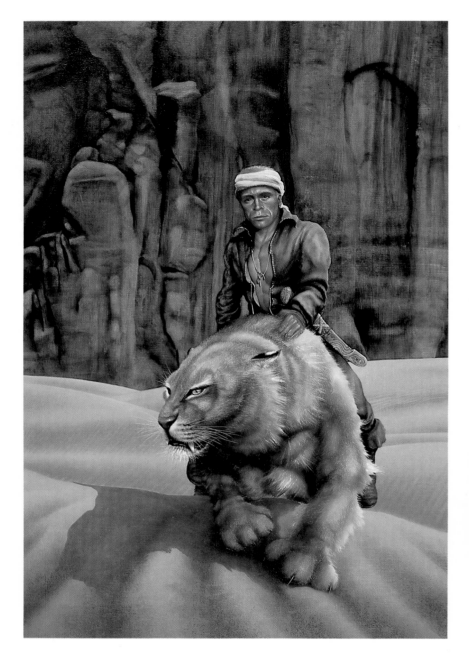

The Steel of Raithskar 1981, Bantam Books, New York

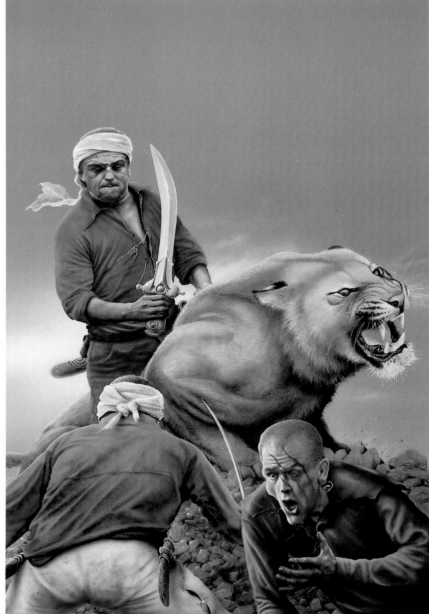

The Glass of Dyskornis 1982, Bantam Books, New York

The early pulp artists and writers had no such qualms about making their invented creatures seem plausible. Cities were commonly menaced by everything from huge termites to walking starfish, while desirable women were frequently abducted by chimpanzees with a very human leer on their faces. Writers and artists are nowadays more obiliged to design their creatures with evolutionary principles in mind. Beasts like huge gas-filled sacs have been imagined populating the rich atmospheres of gas-giant planets such as Jupiter, while the more fanciful tribbles — balls of fur from a *Star Trek* episode — show that alien animals can be used for comic and sentimental effect. But the most effective creatures remain those which look the most familiar. What could be more terrifying than the domestic goat standing on its hind legs — the very Devil himself?

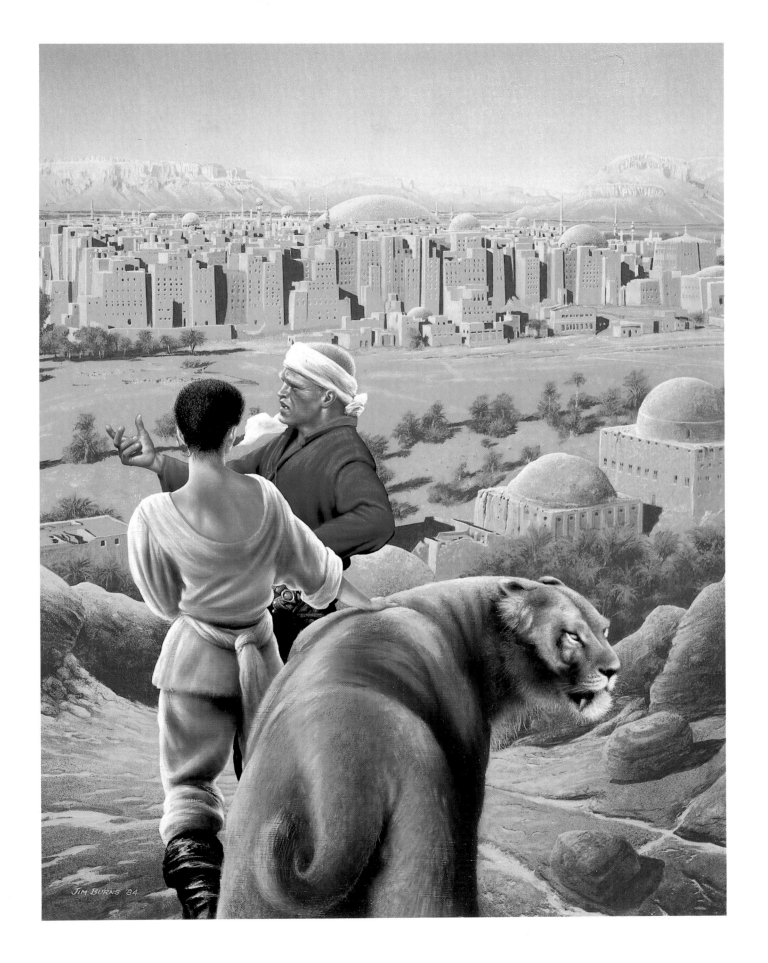

The Search for Ka 1984, Bantam Books, New York

UNFAMILIAR TERRITORY

Science-fiction and fantasy landscapes are the close cousins of those private worlds of our dreams. Both tend to feature strongly the irrational, the unknown, the bizarre juxtaposition of image and event. The paintings of Hieronymous Bosch are like the nightmares of some fevered mind, and art with a surreal flavour is just another way in which we dig deep into the darker corners of our unconscious to dredge up images which startle and disturb. Dali, Magritte, Escher and others helped develop the tradition, establishing much of the visual vocabulary employed by today's fantasy artists who dabble in symbolism.

Speculative literature is, by definition, a genre which lends itself particularly fruitfully to the symbolic cover in which a variety of disparate elements may be combined. In early pulp magazine art, symbolic covers tended to be rare since editors favoured garish representations of rampaging robots and scantily clad females in mortal danger of losing their lives or at least their underwear. Art with a symbolic or surreal flavour is more subtle in its appeal, and it wasn't until the 1950s and '60s that this sort of art began to emerge in magazines, chiefly in Britain rather than the United States, where magazines such as *Science Fantasy* encouraged artists who combined realism

Unfamiliar Territory 1977, Coronet Books

with images from abstract art.

Today it is not uncommon to find book and magazine covers which hint at mental rather than physical states, often using montage which throws all sorts of different images together, or by having objects in the illustration defy the laws of science in a most blatant way. Such illustrations frequently have dream-like qualities, a sense that their landscapes are interior, mental, products of the unconscious human brain.

For the artist, practical or commercial considerations can play a large part in the creation of such images. The artist may be illustrating a collection of stories which range widely in subject matter, and he might wish to suggest the flavour of the whole collection by combining images from different stories. Or a book may contain powerful images which never actually occur together in the text but which must be combined on the cover if the illustration is to do justice to the story as a whole. Another

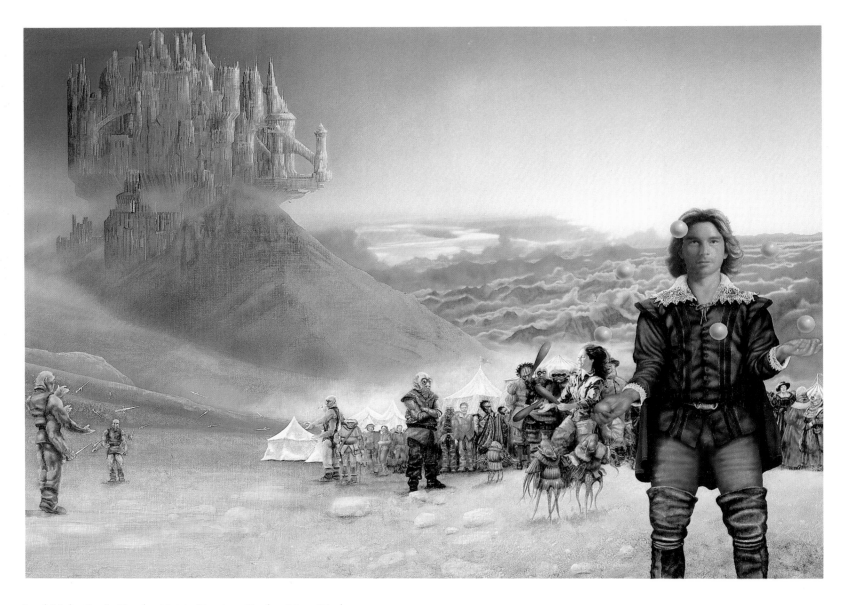

Lord Valentine's Castle 1981, Bantam Books, New York

factor is the way in which science-fiction itself has changed in the last twenty years or so.

Traditional s-f stories tend to deal with futuristic science and all its ramifications, but in the 1960s a change of emphasis took place. The so-called New Wave, whose standard-bearer was the Michael Moorcock-edited magazine, *New Worlds*, began introducing stories and themes which dealt less with hardware and landscapes and more with characters' psychological states of mind. It was J.G. Ballard who coined the apt term "inner space" to describe the territory of such science-fiction.

S-f stories which concentrate on character and mental event at the expense of traditional science-fiction trappings are now an established part of the genre. To some extent they are a consequence of the increasing literacy and self-awareness of s-f writers, of their desire to inject more human interest into their stories by shifting the emphasis from gadgets to people. They are also a result of the wearing-out of genre materials, a process which causes stock figures and motifs such as the robot to lose

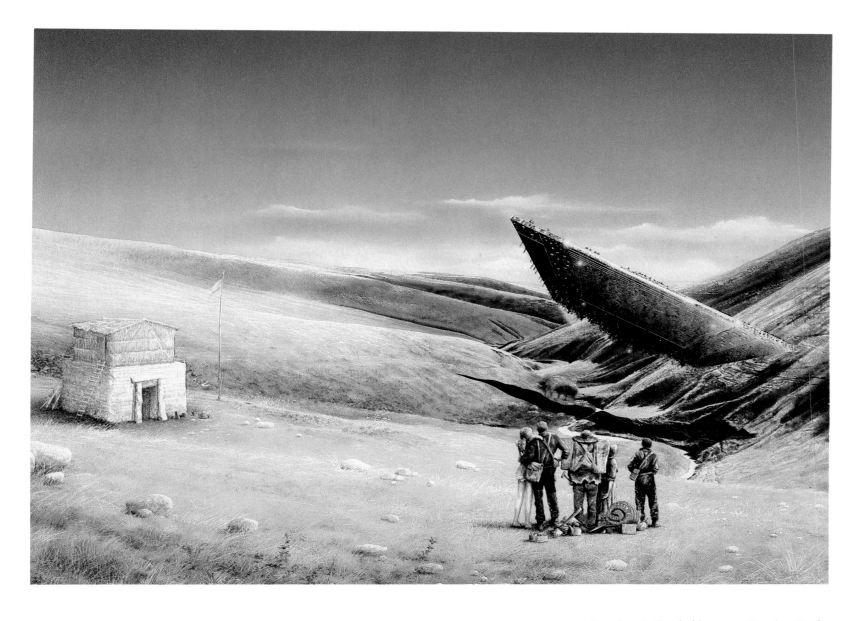

Farnham's Freehold 1979, Panther Books

their surprise or novelty value through over-use. No longer adequate as a source of narrative drive or a framework for speculation, they are relegated to the background of the story while the writer focuses on that most fascinating of all subjects, the human mind.

Science-fiction of this nature may be set in the present day and might not contain any visual element which would immediately identify it as s-f. The story might be an intense study of alienation or madness, told through the thoughts of a single character whose perceptions of the external world may be distorted and unreliable. Or it might concern shifting realities, drug experiences and illusion.

For the artist illustrating such works, all this can pose problems. Publishers are usually keen that a book's category be instantly recognizable from its cover, but sometimes no particular scene from this kind of story would suggest its s-f elements if depicted literally. Or, if such s-f elements *are* present, their portrayal might create totally the wrong ambience for a story in which they are

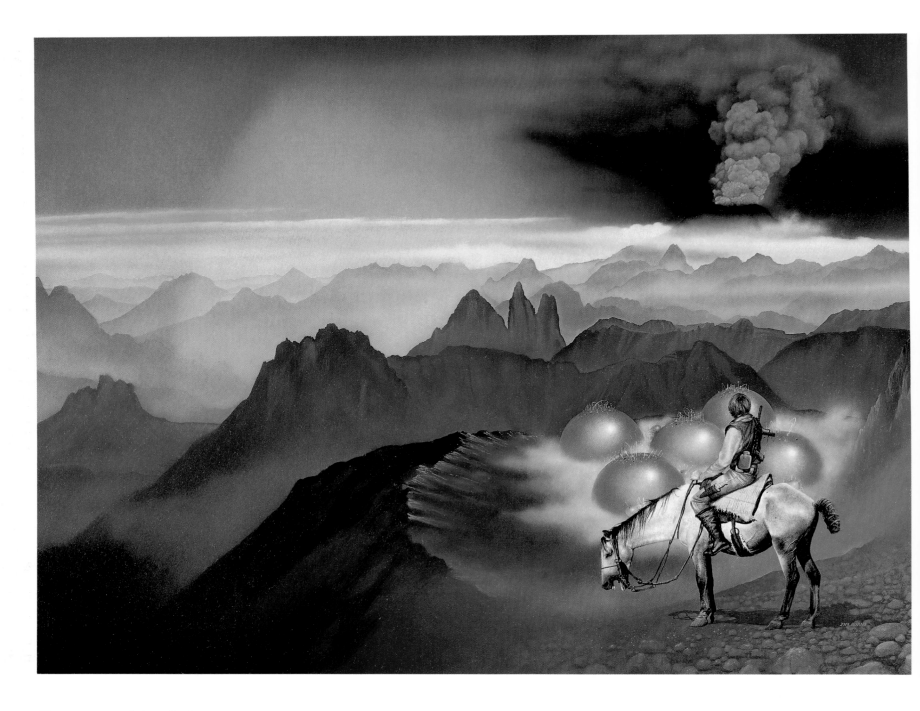

Karma 1980, Sphere Books

minor elements. So the artist may use imagery which symbolizes the story in a manner which suggests that it deals mainly with mental rather than physical event.

Equally often, though, the effect may be purely fortuitous, and Jim Burns has never been aware of such a category when painting pictures to a science-ficiton brief. "To me they are all 'dreamscapes' really. Some illustrations produce their effect by the accidental conjuring up of

an atmosphere which is unsettling in some unspecified way rather than by resorting to the usual cliché s-f props. I'd like to think that almost any successful s-f cover has some of the properties of a dream or a nightmare."

"The illustration to Silverberg's superb *Dying Inside* — which is barely s-f at all — was quite a challenge. I tried to suggest the gradual diminishing and eventual loss within a man of a unique telepathic power and the eventual

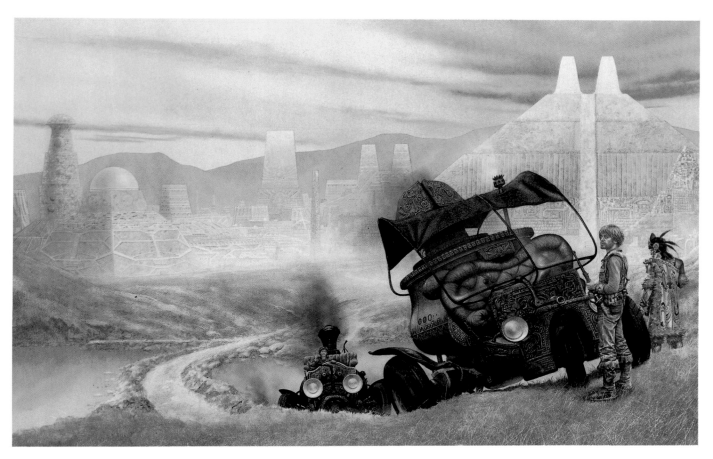

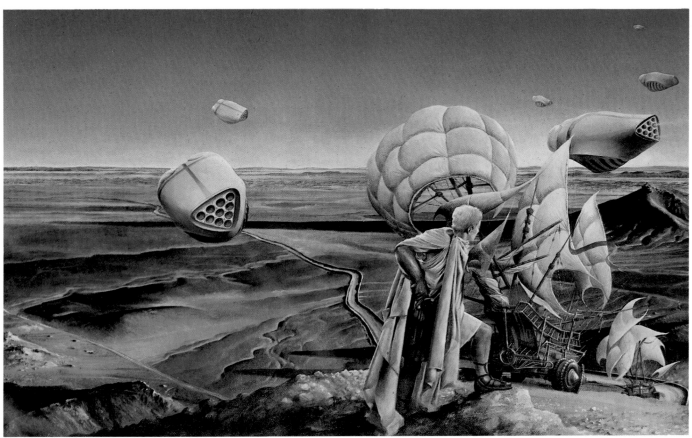

The Gate of Worlds 1979, Magnum Books

The Gray Prince 1976, Coronet Books

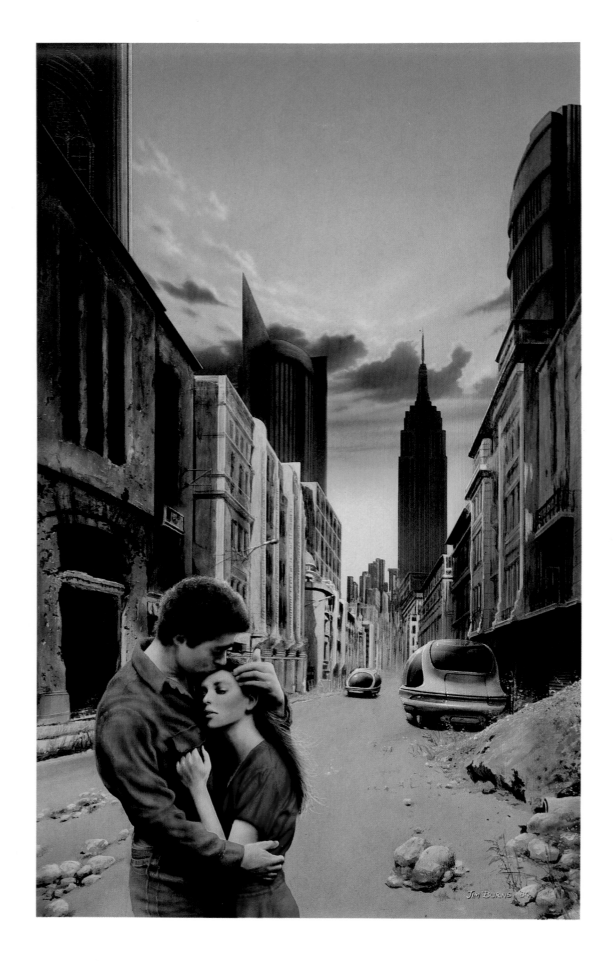

Mockingbird 1984, Bantam Books, New York 38

Emergence 1984, Bantam Books, New York

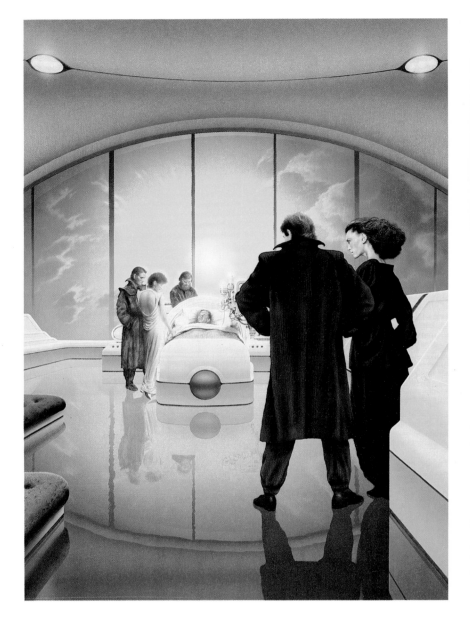

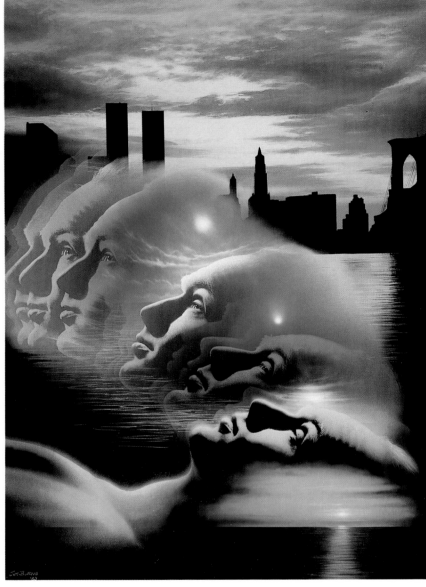

Born with the Dead 1983, Bantam Books, New York

Dying Inside 1983, Bantam Books, New York

discovering of tranquillity when it finally blinks out. In the end I plead guilty to having resorted to a bit of a cliché cop-out — just note the sunset motif! In another Silverberg story, *Born with the Dead*, the effect of a dream is achieved in a different way. Here, although we are in a fairly hi-tech sort of bedroom, which gives the image a notional s-f quality, the dream-like quality is largely achieved through the use of strange, almost monochromatic colour and the stiff and slightly menacing poses of the figures in the room. I feel that a genuinely unsettling 'bad dream' atmosphere starts to come across."

Burns enjoys the challenge which such borderline works of science-fiction present to him as an illustrator. "To try and push the boundaries of s-f imagery out into these broader areas is to do no more than follow the very healthy tendency of the literary form to explore altogether more rewarding and 'serious' avenues than in the past."

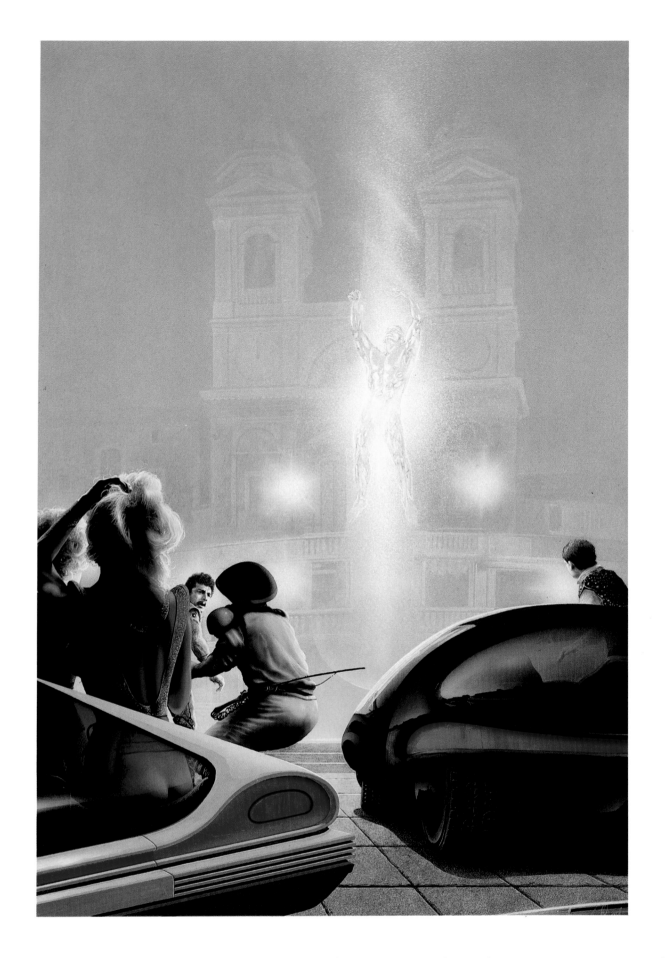

The Masks of Time 1983, Bantam Books, New York

PLANET STORY

Most illustration work in the science-fiction genre is for paperback covers or wrap-around dust-jackets for hardbacks. Such work is done for a flat fee, with no advances or royalties being involved. Publishers' briefs are often limiting, but Jim Burns also sees advantages in doing this kind of illustration. "Everything starts afresh with each job, and there's no need to worry about any sense of continuity in the depiction of characters or landscape. If a job is less than successful, it's still a one-off which can be forgotten about and which doesn't mar in some way a larger-scale collection of work."

Even so, frustrations often do build up with cover-art over a period of time. "It's quintessentially commercial, for a start, with very little opportunity for personal exploration within the confines of the brief. The proportions of the illustration are pre-ordained, deadlines are usually tight, and there's the ever-present require-ment to leave uncluttered by imagery the top third or so

of the picture for lettering. Any pretension to self-expression can be ground underfoot by the demands of the market."

Most commercial artists enjoy the opportunity to produce work which allows them more freedom of expression. Illustrated books, a flourishing area of publishing, are one way in which they can often achieve this. "A browse through the pages of a well illustrated book brings home the potential strength of that medium. It's where illustration perhaps comes closest to being truly identifiable as a legitimate art-form rather than just the poor relation of 'proper' painting. Just look at a late-Victorian book illustrated by, say, Arthur Rackham or Aubrey Beardsley, working during what was a Golden Age of book illustration, and the point is soon made."

Jim Burns had his own opportunity to produce an illustrated book with *Planet Story*, which appeared from Pierrot Publishing in 1977. The project began with a

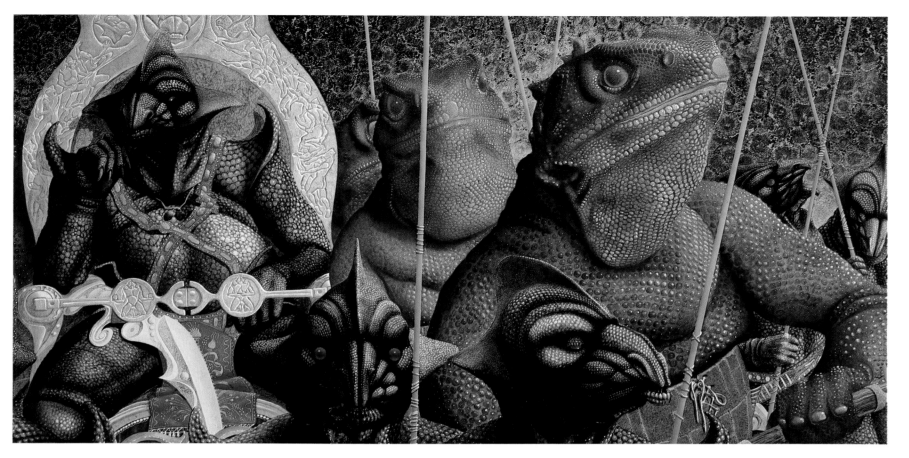

Planet Story – King Kroakr 1978, Pierrot

Planet Story – Scoutship Pilot 1978, Pierrot

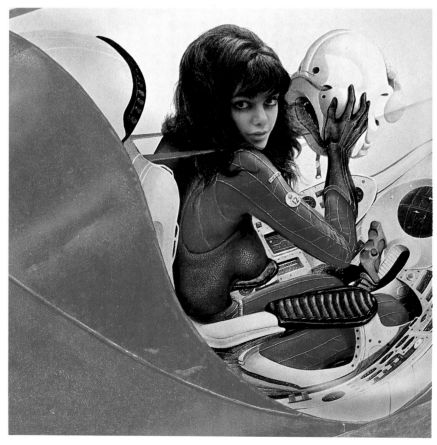

telephone call from an author whose novels Burns had illustrated in paperback. The author was also a publisher of large-format picture books, and he was so pleased with Burns's covers that he offered him the job of illustrating a novella which was to be written by the well-known s-f writer Harry Harrison.

A meeting was arranged between the three to thrash out initial concepts, and in due course a contract was drawn up with Burns's agent. "One very satisfying aspect was that of payment. For a period of two years I would receive a monthly cheque — and a generous one at that, compared with my earnings at the time. These sums would be offset against any royalties I might earn from the sales of the book."

The prospect of a "salary" for two years was very welcome to Burns since publishers were often late in paying their flat fees for cover illustrations. "I was also fully aware of the responsibility. It's an enormous

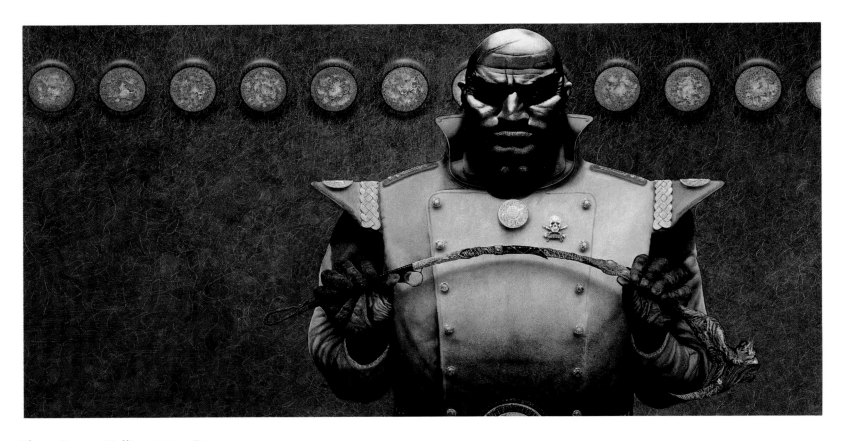

Planet Story – Kylling 1978, Pierrot

expression of confidence in you on the part of the publisher when you're given a job like that." The project also gave him the opportunity to take up oils seriously instead of the gouache which he had been finding an onerous medium in which to work.

"Harry Harrison's story turned out to be in an ebullient and humorous style, and I found plenty of material for pictorial representation. The pictures needed to be selected carefully and were determined in part by the need to space them out sensibly. Between 25 and 30 were required — we ended up with 28 — just upward of one a month for two years, and leaving me time to fit in the occasional cover-job so that I could maintain the working relationships built up with different publishers over the years."

Another pleasant surprise soon materialized. Every job Burns had undertaken before *Planet Story* had required a rough of some sort. Now he was asked to select an appropriate scene from the book and do a full illustration to see whether sketches would be needed for the others.

He duly did so, portraying the vast space battleship U.S.E. *Execrable* rushing through deep space towards the planet Strabismus. This was well received by the publisher, who then allowed Burns a free hand to choose scenes and deliver the finished pictures when they were completed.

"This set the scene for an enjoyable and rewarding couple of years' work — a time which spoilt me in a way. Everything has seemed so much harder since. So often a job that is tightly briefed feels a little like painting by numbers. You begin to wonder why the art editor doesn't paint it himself, or send you a drawing with a brief to colour it in. The *Planet Story* paintings were the complete opposite. Every one of them was an experiment both compositionally and in terms of technique."

This was the first time that Burns was really able to "splash things around a bit". He created random background effects with thinned oils, used dry-transfer lettering and textures overlaid with air-brushed glazes; he cut out canvas-textured oil sketching sheets to various shapes and stuck them down on his illustration board to

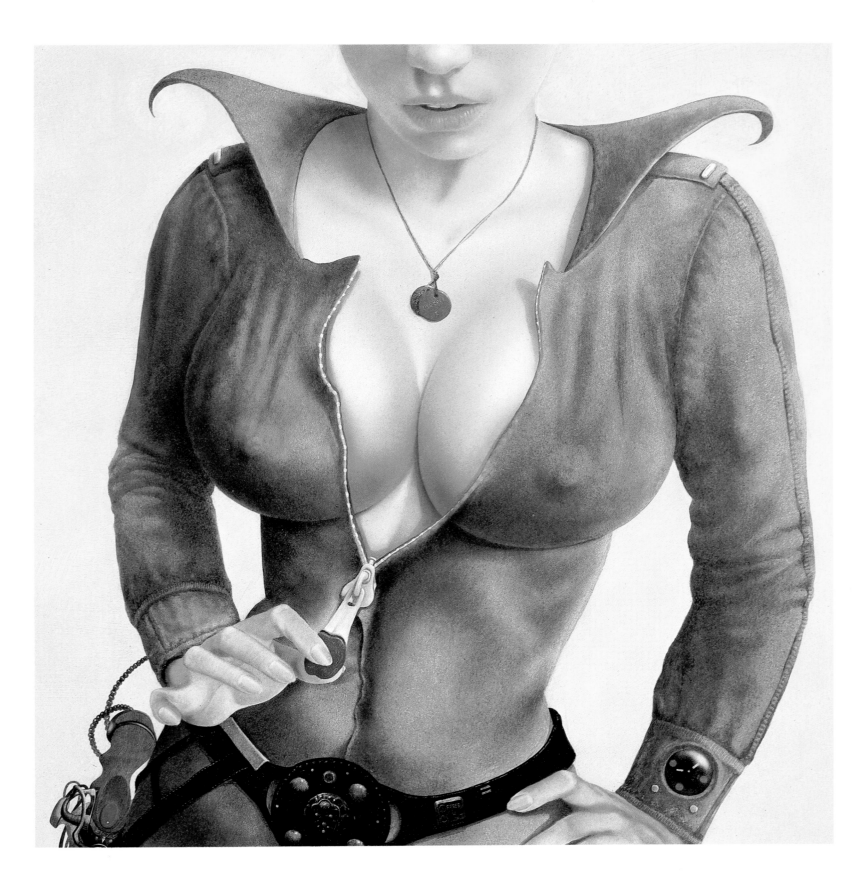

Planet Story – Styreen Fome 1978, Pierrot

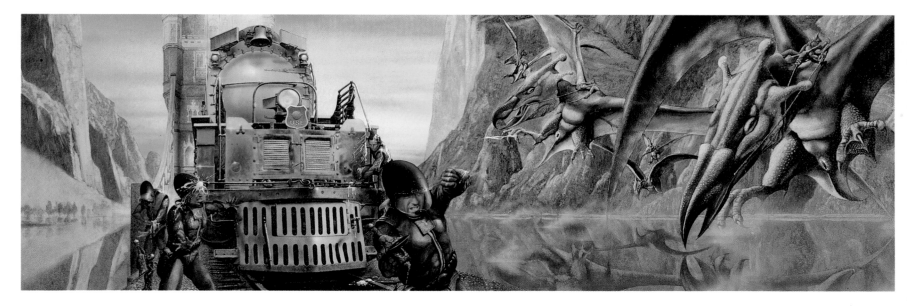

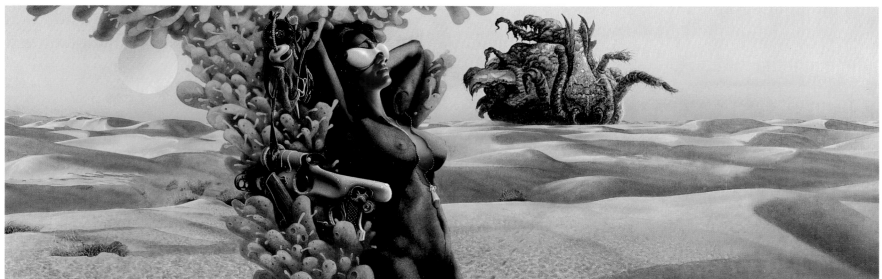

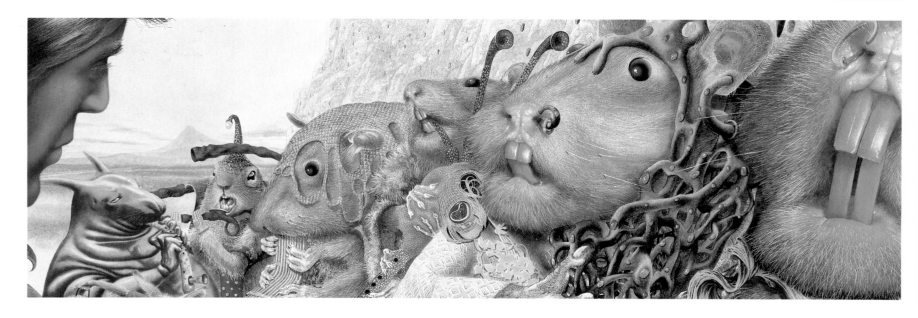

Planet Story – Dive-crapping 1978, Dune Buggy 1979,
Rats 1979, Pierrot

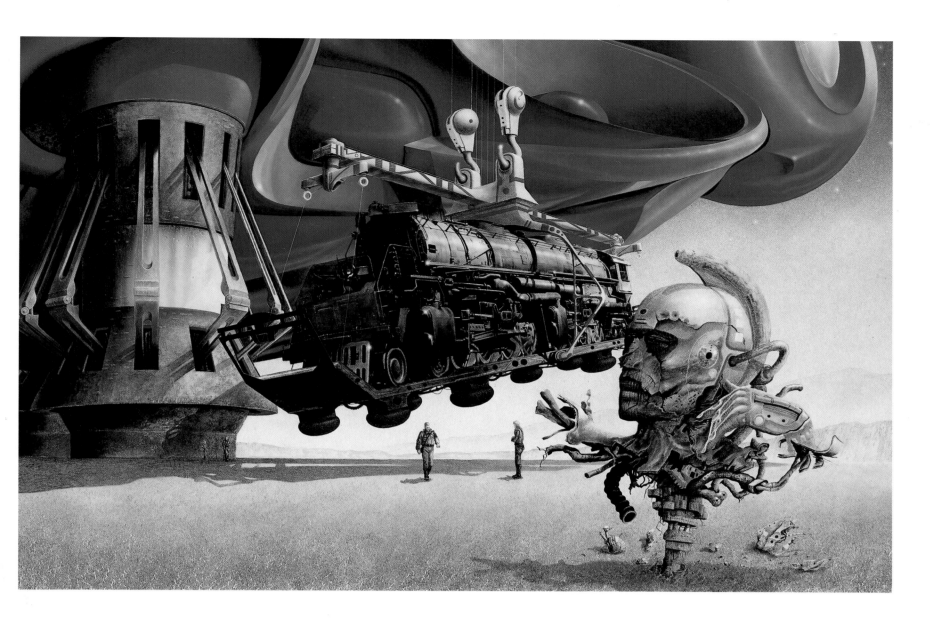

Planet Story – Big Boy Loco 1978, Pierrot

give contrasting effects. "It truly liberated me from an attitude to my work which was timid, rather precious, clinical and blinkered. I think each painting improved as my confidence increased, and in the end self-confidence in my work was the most valuable thing I got out of the whole project."

Viewing the *Planet Story* pictures as a whole, Burns sees them as something of a pot-pourri. "The illustrations lack consistency perhaps, though others have seen this as variety. What I hope they are is entertaining, which is what I like to think all my work is about. I discovered that

it was possible to introduce a bit of wit into my pictures — science fiction can be a bit po-faced sometimes. The order in which the paintings were completed was pretty random — they don't follow the story chronologically."

Pierrot Publishing folded shortly after *Planet Story's* publication, so it's not surprising that the book wasn't a great success commercially. But for Burns it remains a valuable experience. "In two years I was able to advance my skills by the equivalent of perhaps five years for the more usual, more mundane book-jacket art. I think if a similar opportunity arose now, the same would be true."

48/49 Planet Story – Execrable 1978, Pierrot

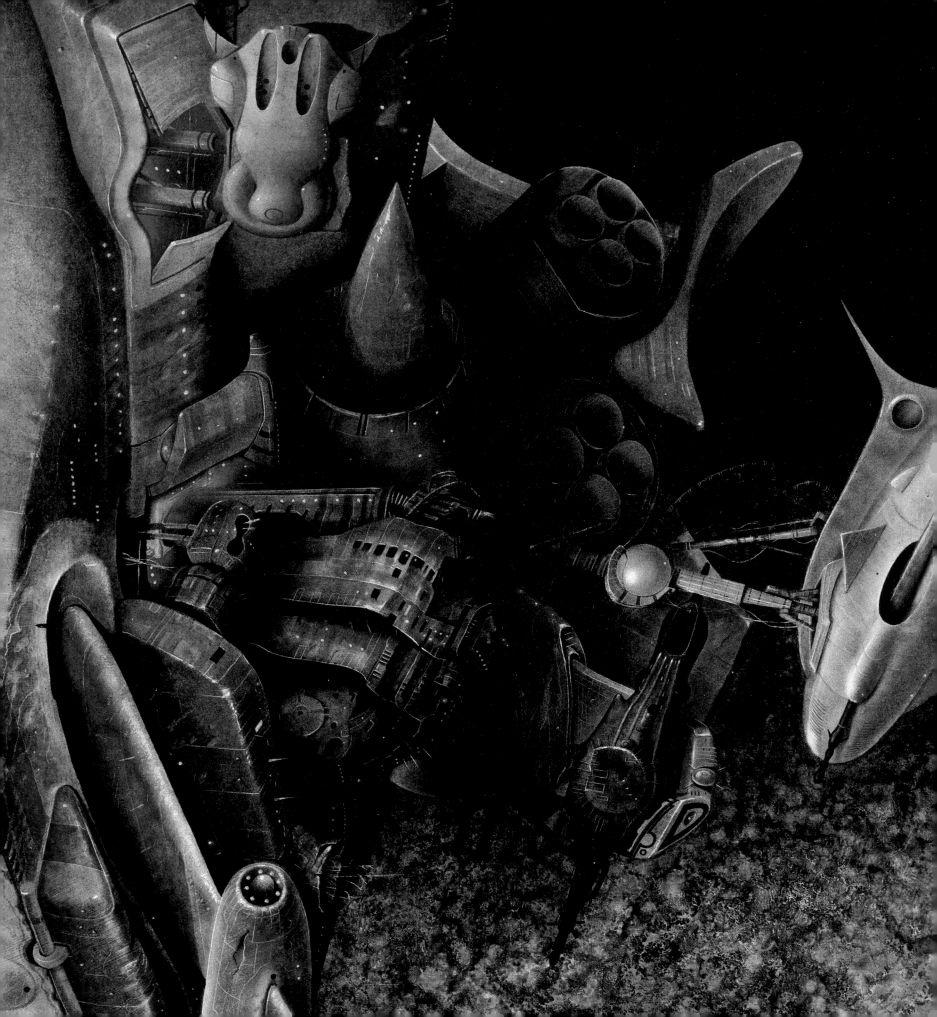

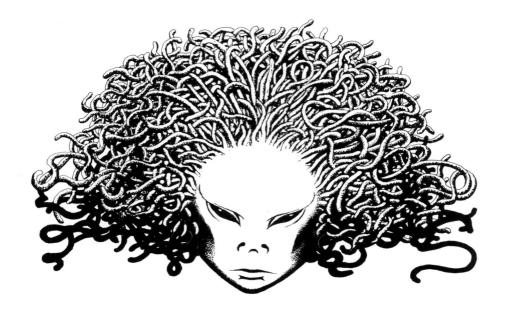

MORE THAN HUMAN

Pictures tend to be more interesting if they contain human characters — or characters which look like humans but aren't quite. In science fiction the range of humanoid creatures runs the gamut from ordinary people to strange aliens only loosely based on human forms. In between it also includes artificial humanoid creatures with a bewildering variety of names — robots, androids, automatons, cyborgs, replicants, and so on.

For the purposes of this chapter *robot* is taken to mean an automated device, obviously mechanical, but with only a crude resemblance to the human form. By *android* is meant an artificial creature which strongly resembles human beings (even to the point of indistinguishability) but which is actually made of metal or has been synthesized from biological materials. The word *humanoid* is used as an adjective to describe creatures, whether artifical or alien, which resemble human beings in the sense that they stand upright, have arms and legs and a head with the sensory organs in roughly the same places as our own. The other terms are ignored for the sake of clarity and simplicity. For a discussion of non-humanoid aliens, see Chapter 10.

Machines and creatures based on human shapes have fascinated people since early times, and the robot, android and alien are three of the most potent symbols in science-fiction. It's not hard to understand why. The scariest monsters are not the King Kongs and Godzillas but the Draculas and Frankensteins, which look like human beings and hence remind us of the dark sides within ourselves. At the other extreme, higher human aspirations are frequently represented by figures such as the superhuman and the angel. These embody transcendent qualities in recognizably human form, but science-fiction frequently portrays them with scepticism and even hostility. We fear our potentials as much as our primitive pasts, and the more such beings resemble us, the

Mechanismo Spaceport 1978, Pierrot Publishing

more our identification with them is coloured with unease.

The robot has been a favourite figure with science-fiction artists from the early days of the pulp magazines, and most were given a vaguely humanoid form. To begin with, they were often portrayed running rampant like latter-day Frankenstein monsters, destroying cities, kidnapping humans and generally making nuisances of themselves. The illustrations tended to show them as assemblages of boilers with hinged arms and legs, though occasionally they were insect-like or took the shapes of walking missiles. Often there were hordes of them, all identical.

This was a period (roughly 1930 to 1960) when automation was playing an increasing part in people's lives, so it's little wonder that the robot frequently became the symbol of human concern over whether we could control the technology we were creating. It was also a period of war against the Germans and Japanese, and later of the Cold War against the Russians, all of whom tended to be perceived as faceless stormtroopers, mindlessly driven by the power of ideology. Marching ranks of identical robots symbolized their threat to democracy and libertarian ideals.

At the same time, however, a more sophisticated view of the robot was developing within the s-f field. Science-fiction writers were beginning to tame the robot, to make him a servant rather than an oppressor of humanity. In 1940 Isaac Asimov codified his now-famous three laws of robotics which were to influence the treatment of robots in fiction during the post-war years:

1. A robot may not injure a human being or, through inaction, allow a human being to come to harm.

2. A robot must obey the orders given it by human beings except where such orders would conflict with the First Law.

3. A robot must protect its own existence as long as such protection does not conflict with the First or Second Laws.

From this time on, writers and artists tended to portray robots more sympathetically and gave them more human qualities. Some even began to use them for comic or ironic effect, a measure of how much our fear of the machine had begun to diminish. But people need bogey-men, and as the robot was humbled and domesticated, so it began to lose its dramatic appeal in favour of the android.

The android is a brother to the robot, but in most respects it's a more sophisticated, ambiguous and unnerving symbol. In appearance it's more humanoid than machine-like, often to the point where the difference between android and human is unknowable to the external observer. Its replacement of the robot as bogey-man in science-fiction reflects not only the modern need for less crude images but also owes something to the spirit of the times.

If the mad robot represents technology run rampant, the mad android represents ourselves turned into machines. Techno-horror stories are still popular, but computers rather than robots now tend to be the villains of the piece, and these are more cerebral in their symbolism rather than mechanical. Most of us have grown up in a technological world, and in a practical sense we take machines for granted. If they malfunction, we expect inconvenience rather than outright danger. But while we may have accepted that they pose no direct threat to us physically, the modern tendency is to fear that they are dehumanizing us. And what is the android but the human who is a machine?

Two of the most potent images in recent science-fiction cinema are the scenes in *Blade Runner*, where a damaged android flails about frantically at inhuman speed, and the moment in *Alien* when a member of the ship's crew is

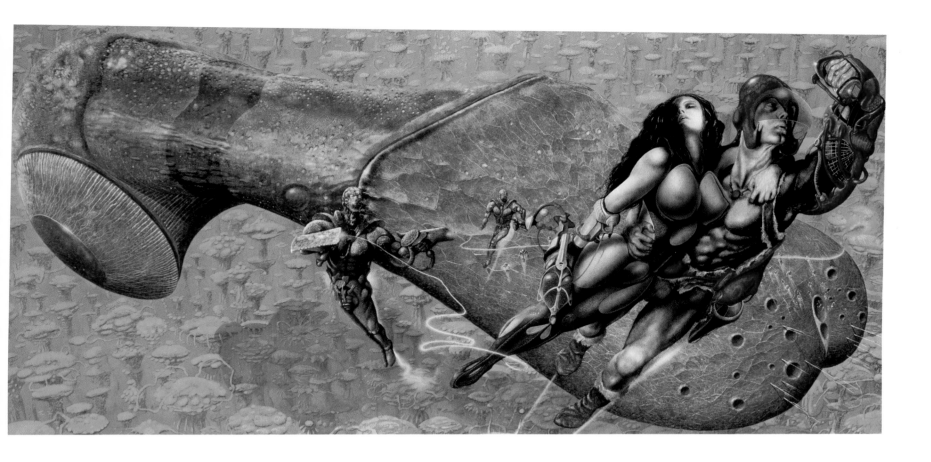

Great Balls of Fire 1977, Pierrot Publishing

suddenly revealed to be an android after his head is knocked off his body. (Interestingly, both of these films were made by Ridley Scott.) The flailing android manages to combine the symbols of both technology and humanity gone mad, while the dismembered head in *Alien*, which continues talking for long, unsettling minutes afterwards, is terrifying because up to that point we had assumed that the character was an ordinary human being.

Philip K. Dick was a science-fiction writer perenially fascinated by the relationship between humans and machines made in their image. (*Blade Runner* was based on Dick's novel *Do Androids Dream of Electric Sheep?*) Dick's stories deal constantly with questions of identity and reality, frequently with reference to constructs which are perfect replicas of humans or animals. In this respect he is a quintessentially modern writer, constantly articulating one of the major dilemmas of late twentieth century humanity, the problem of what is real and reliable. We live in a world swamped by images and information from a variety of different media. But how accurately do the images represent the reality they are portraying? How do we separate fact from opinion, fakery or illusion? The android is a powerful symbol of our fear that other people may not be as they seem. Strip away the mask and what will you find? Beneath the smile of a friend or lover, does there lurk a thing of cold metal and plastic?

Androids, then, are symbols of dehumanization and psychological doubt; but they're also something more. The word "android" means "man-like", and the usual assumption with such beings is that they have been created by humans. But even if they look exactly like ordinary people, they have invariably been designed to be stronger, tougher and usually more intelligent. So their symbolism often overlaps with that of the superhuman, and they threaten us with their potentials, with the

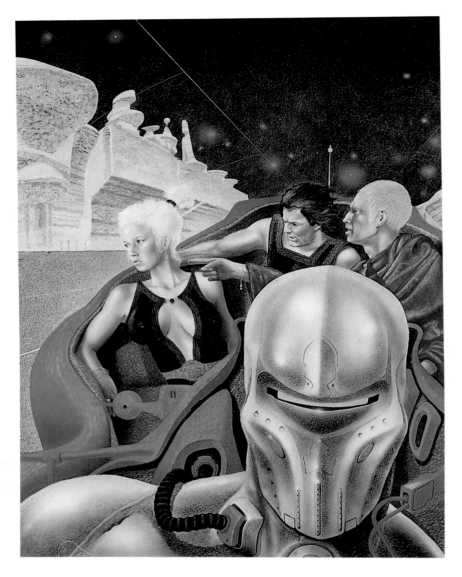

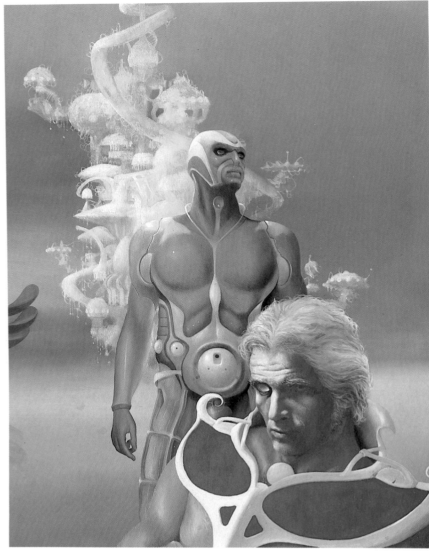

Slaves of Heaven 1977, Coronet Books

Steeleye 3 (Waterspace) 1976, Coronet Books

danger that they may supersede us as dominant beings.

In modern science-fiction illustration, the android who is to outward appearances exactly like a human being is often shown with parts of its flesh torn away to reveal the metal gears and hydraulic joints beneath. Something of this sort is necessary, of course, because otherwise there may be no means of knowing that the figure is meant to be an artifical human from the illustration alone. More subtle ways of suggesting artificial origin include giving the human-looking android different colour eyes or hair, or by having it adopt postures which would be awkward or impossible for a normal human being. But in these cases we may introduce an ambiguity: is the being an android or, another favourite of s-f writers, an alien disguised as a human?

The alien is another central figure in science-fiction literature and art. Most illustrations feature humanoid aliens, not least for the practical reason that it can be difficult to suggest in a picture that non-humanoid aliens are actually intelligent creatures if they look like seaweed or blobs of protoplasm. Humanoid aliens also pack more of a dramatic punch, particularly if they resemble us strongly.

Aliens have come a long way from the bug-eyed

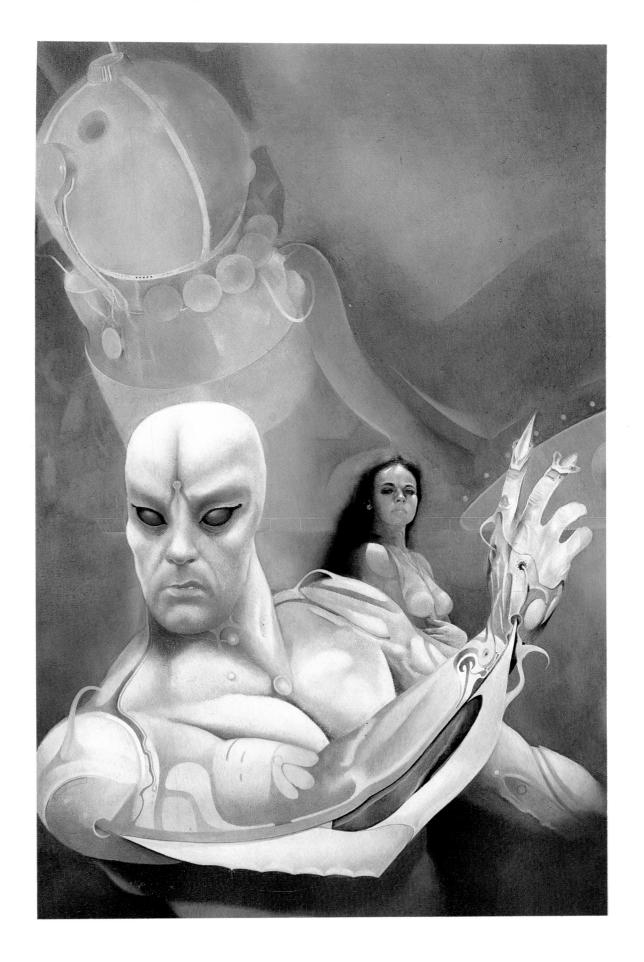

Three Eyes 1976, Panther Books

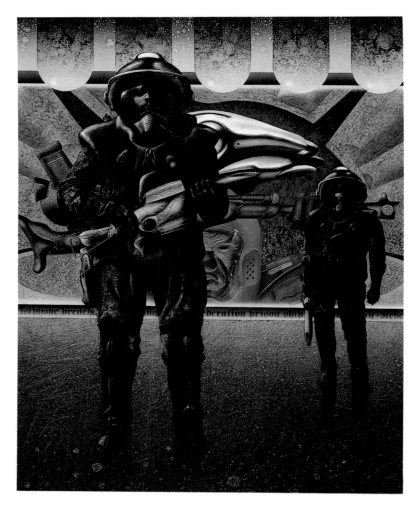

Tour of the Universe – Mural 1980, Pierrot Publishing

monsters of pulp magazine covers. In fact, from the earliest days of the pulps, artists depicted a wide range of humanoid beings, and occasionally serious attempts were made to take into account the effects of planetary environments on alien physiques. One of the best known pulp artists, Frank R. Paul, produced a back-cover illustration for *Fantastic Adventures* in 1939 which showed a Martian designed on the basis that Mars has a thinner atmosphere, a lower gravity and greater extremes of heat and cold than Earth.

The resulting creature had sucker-like feet, long thin legs, a huge chest to make the most of the thin air, retractable eyes and nose to protect it from great heat and cold, large ears to catch weak sounds in the tenuous

air, and antennae to pick up telepathic communications from other Martians. As a final flourish it carried "an atomic rifle, the result of greater science knowledge".

By today's standards the illustration is crude and comical, but at least the Martian is shaking hands with a space-suited human in the picture rather than trying to blast him into oblivion. The scientific considerations underlying the illustration prefigure much modern work. Nowadays most writers and artists are concerned to make their invented aliens look evolutionarily plausible rather than simply plastering polyps, fins and tentacles over them willy-nilly.

Writers and artists favour humanoid aliens precisely because they are similar to us. When contemplating

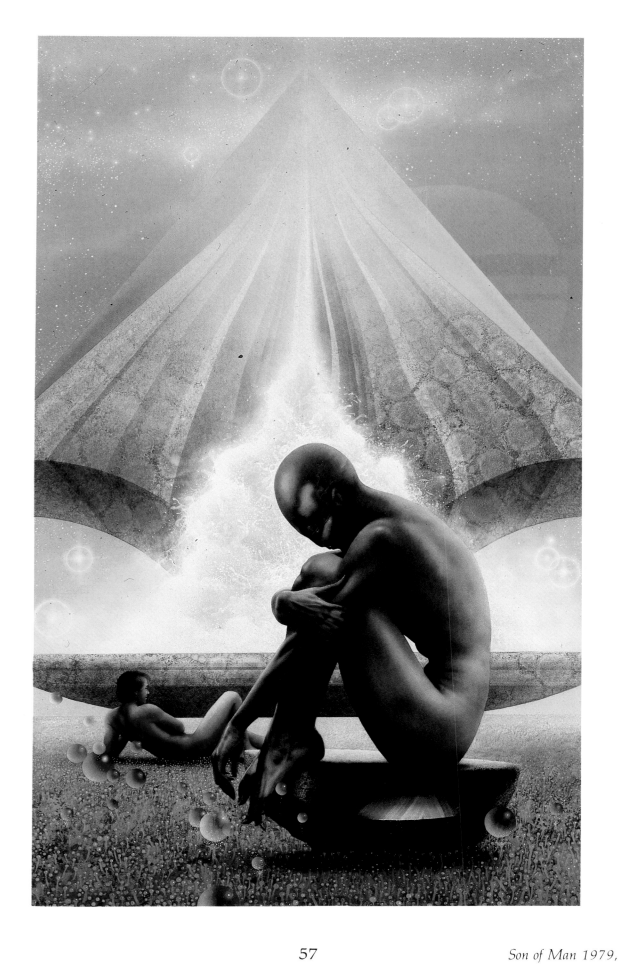

Son of Man 1979, Panther Books

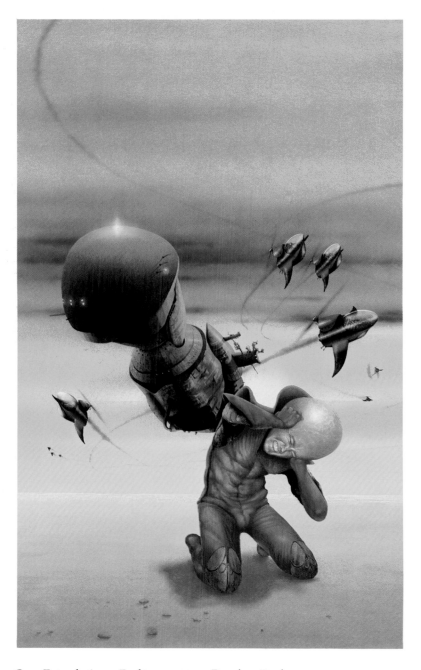

Our Friends from Frolix 8 1975, Panther Books

advanced beings existing on other planets, we tend to assume that evolution has taken a parallel course to Earth. Aliens will be tool-users, and so will walk upright with their hands (or their equivalent of hands) free to manipulate objects. They will have stereoscopic vision, and hence two eyes. And their heads, just like the heads of all creatures on Earth, will be at the top of their bodies. And so on, until we end up with beings whose overall shape mimics our own.

Jim Burns certainly likes his aliens to look as if they've been biologically designed to fit their particular ecological niche. Some of his most striking pictures show humanoid

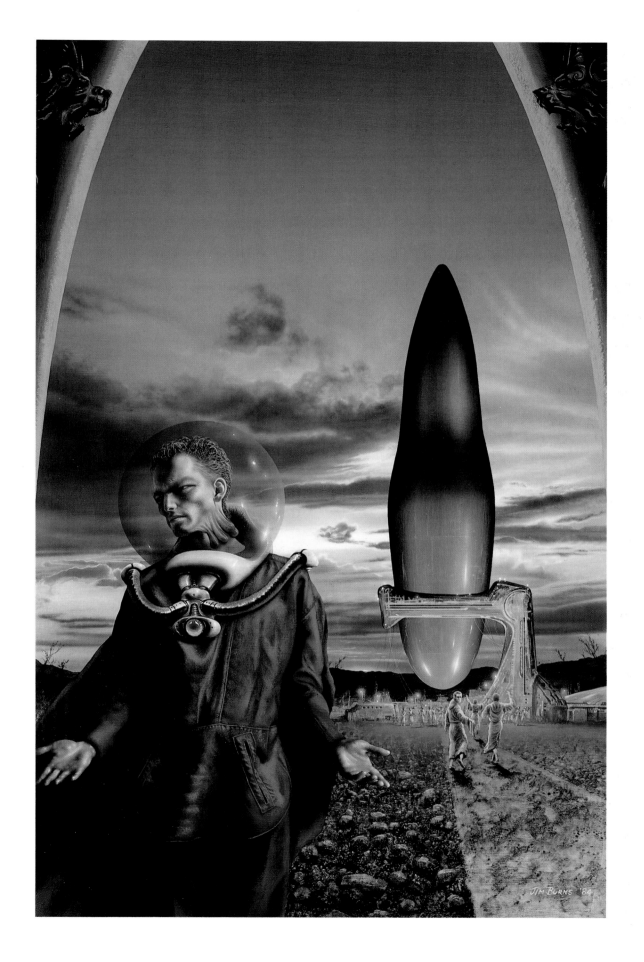

To Open the Sky 1984, Bantam Books, New York

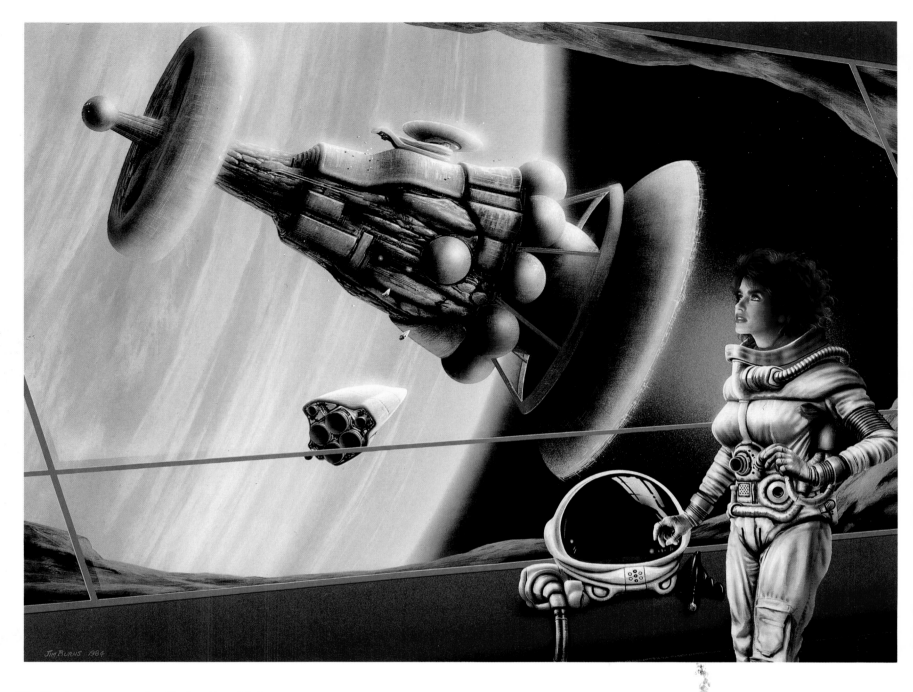

Worlds Apart 1984, Ace Books, New York

alien females whose sexuality is immediately obvious. Such creatures stir strange reactions in us which combine fascination and repulsion. An eloquent testimony to this is a letter from a man which Burns received concerning the book *A Guide to Fantasy Art Techniques*, which featured some of his illustrations:

"On turning a page I was presented with a face that means something far more than I can properly explain — it was the face in your painting *Mortal Gods*. Something registered akin to what I can only describe as recognition deep in my mind, but for the life of me I do not know why, as the feeling goes far beyond simple interest or mere recollection. The face is symmetric and geometrically attractive, well balanced in its basic construction ...

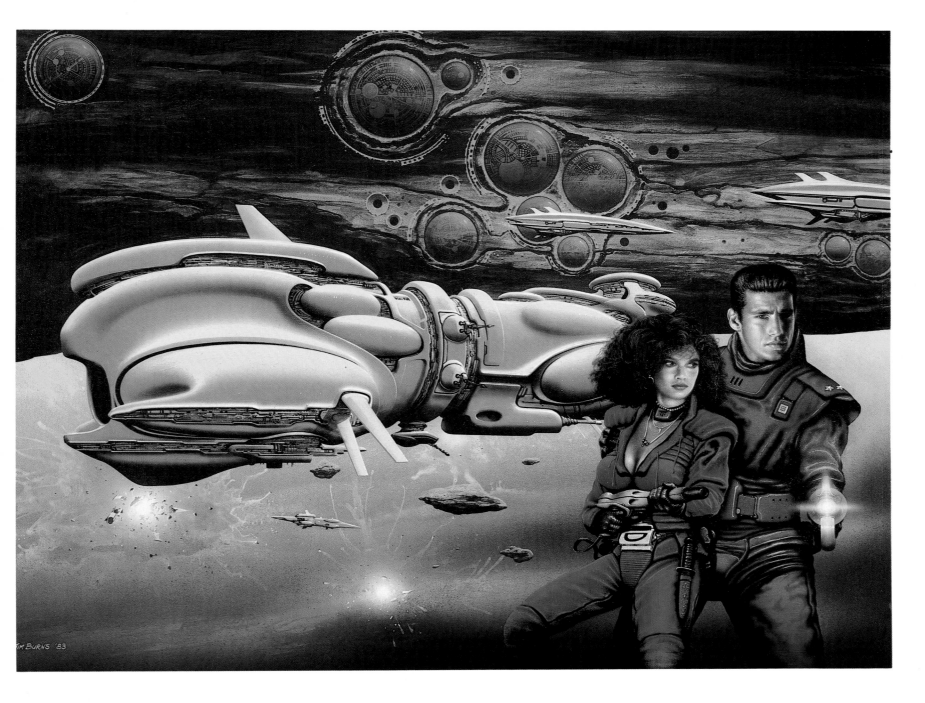

Bio of a Space Tyrant 2 – Mercenary 1984, Avon Books, New York

However, no matter how I analyse it, there is something more . . . When I first saw this face I spoke loud the words in my mind — 'I know you'."

This hypnotic sense of identification mixed with uncertainty is not surprising, particularly since Burns's alien women are usually counterpointed elsewhere in the illustration with ordinary human males. Such pictures tend to dramatize most starkly the basic sexual tension between man and woman, acknowledging the common male fear of the female as temptress, seductress, as dangerously different from man and ultimately unknowable by him.

Jim Burns points out, however, that the concept of the bizarre, frightening female alien who is still sexually

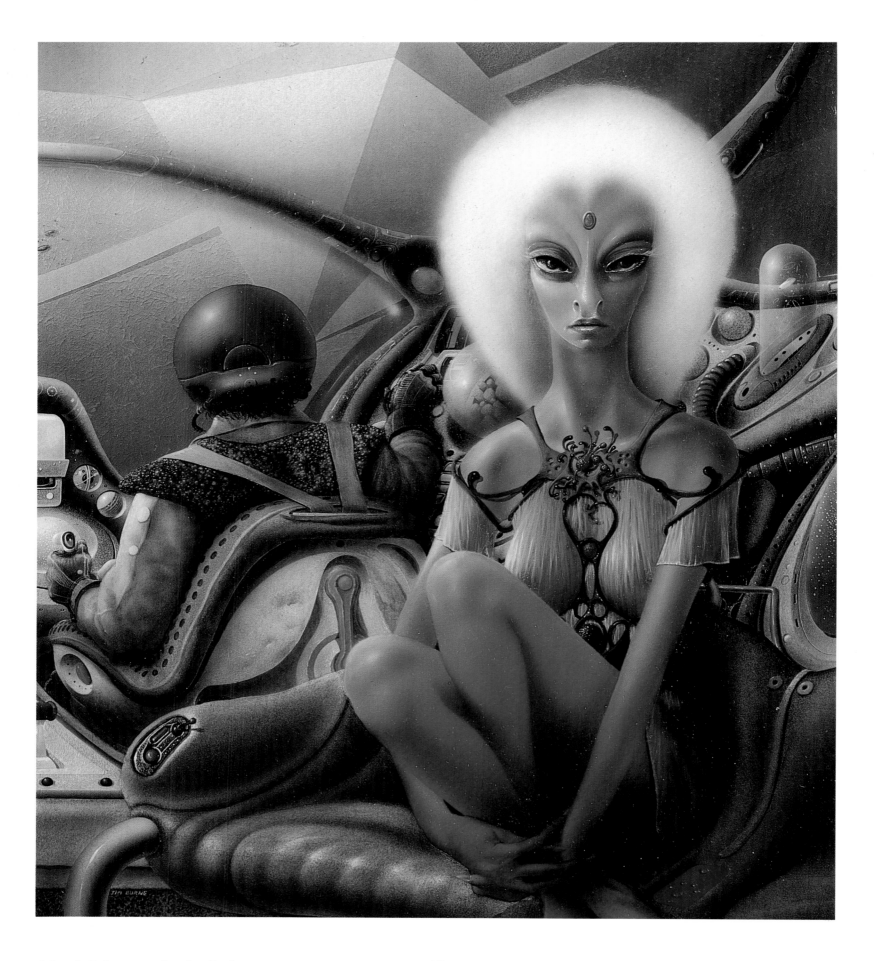

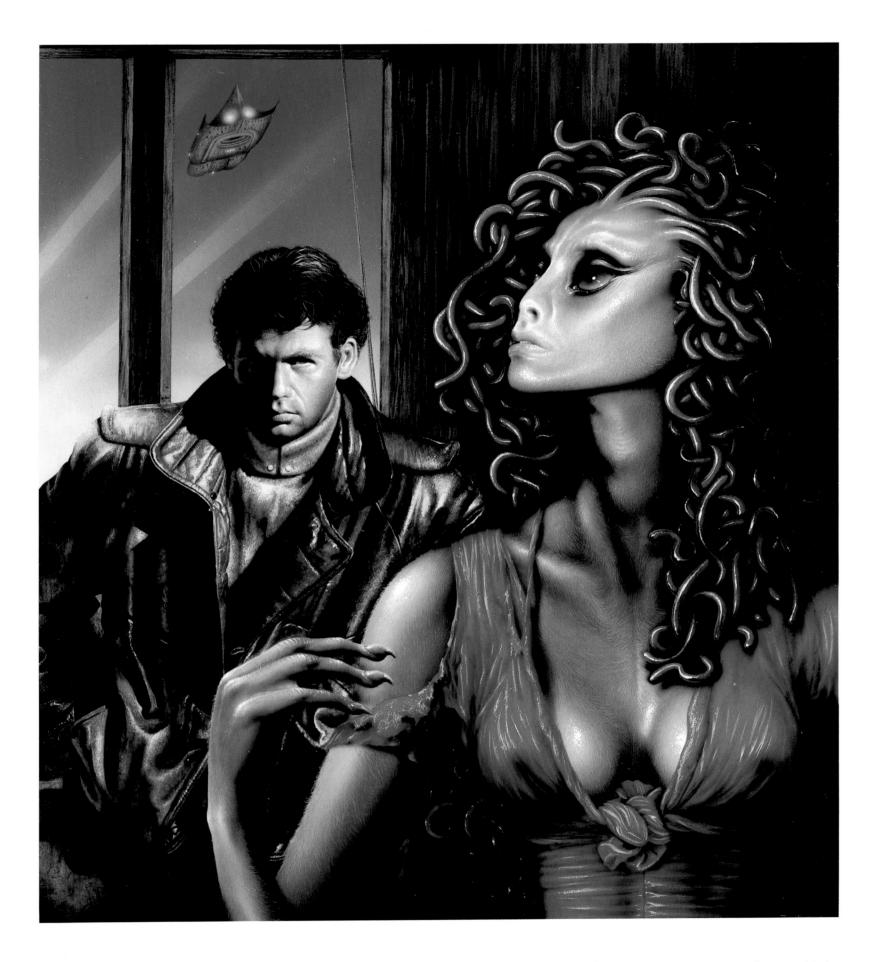

Northwest Smith 1982, Ace Books, New York

The Marcus Device 1981, Bantam Books, New York

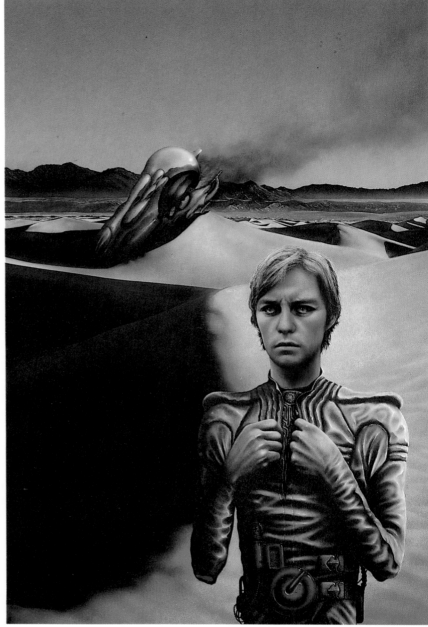

The Man who fell to Earth 1981, Bantam Books, New York

alluring frequently comes from the writer rather than the artist. "This kind of thing is *not* the sole property of the warped male mind. Take *Northwest Smith*, for example. The stories in that collection were written by a woman — C.L. Moore. The cover is based on a superbly crafted little tale about a creature from whom sprang the Medusa legend. I wanted to get across the same combination of allure and horror as the writer does in the story.

"In this kind of image I will usually start with a standard human female and start to push and pull at the details until a point is reached where the tension between the insidiously attractive and the rather horrible gets called to a halt and further manipulation would simply upset the balance. This is a technique I use in a great many pictures. The sense of familiarity lies in the fact that beneath the added veneers of strangeness lies a recognizable figure —

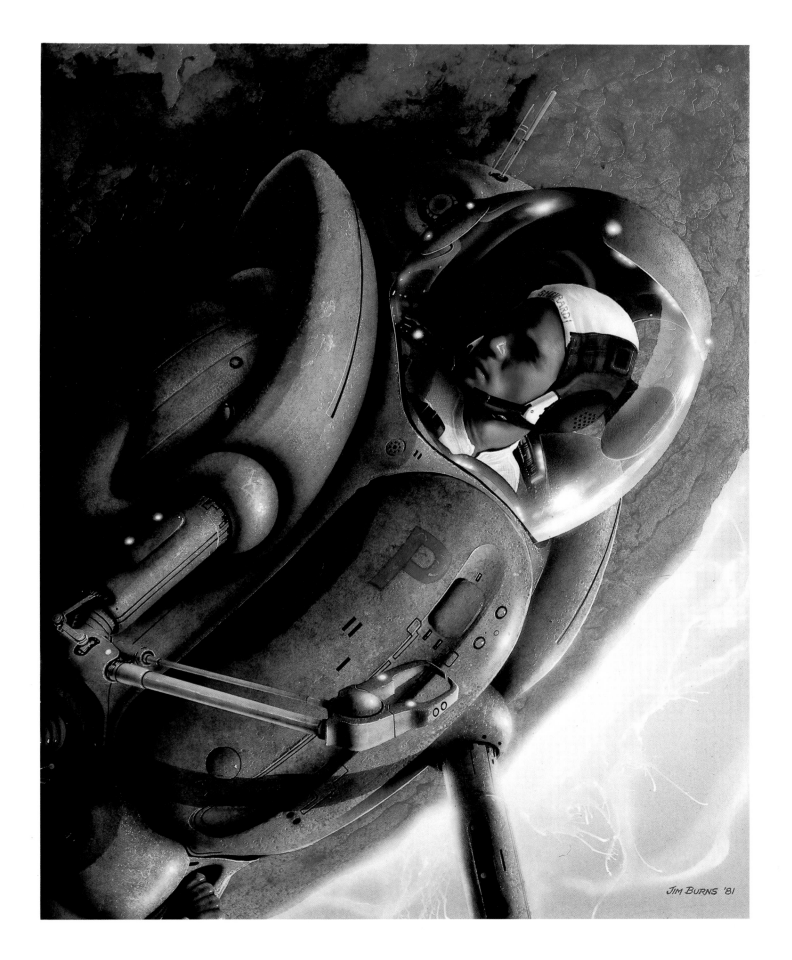

The Best of Arthur C Clarke 1956-1972, 1981, Sphere Books

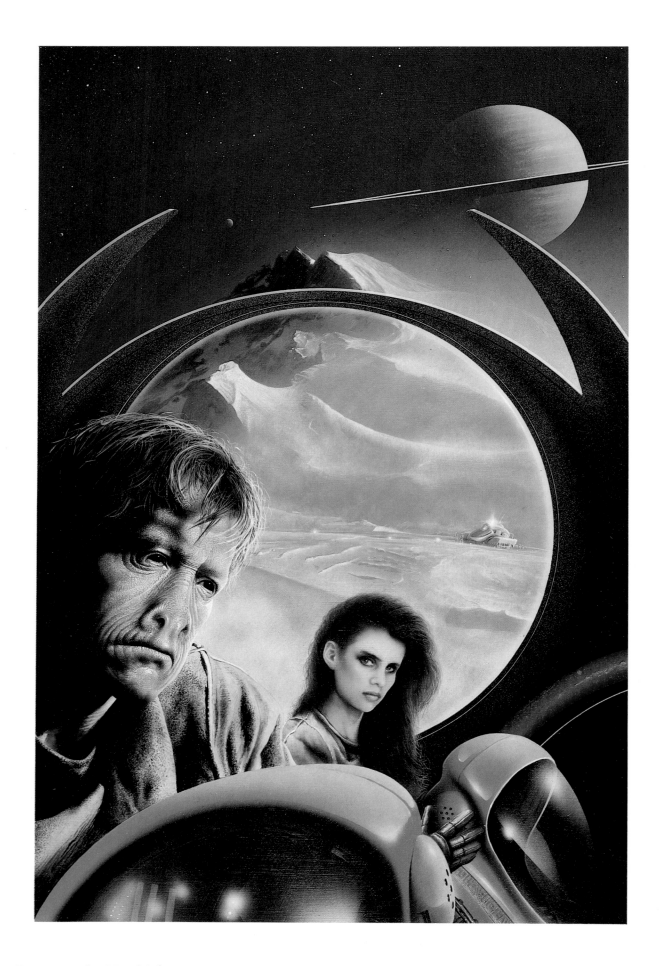

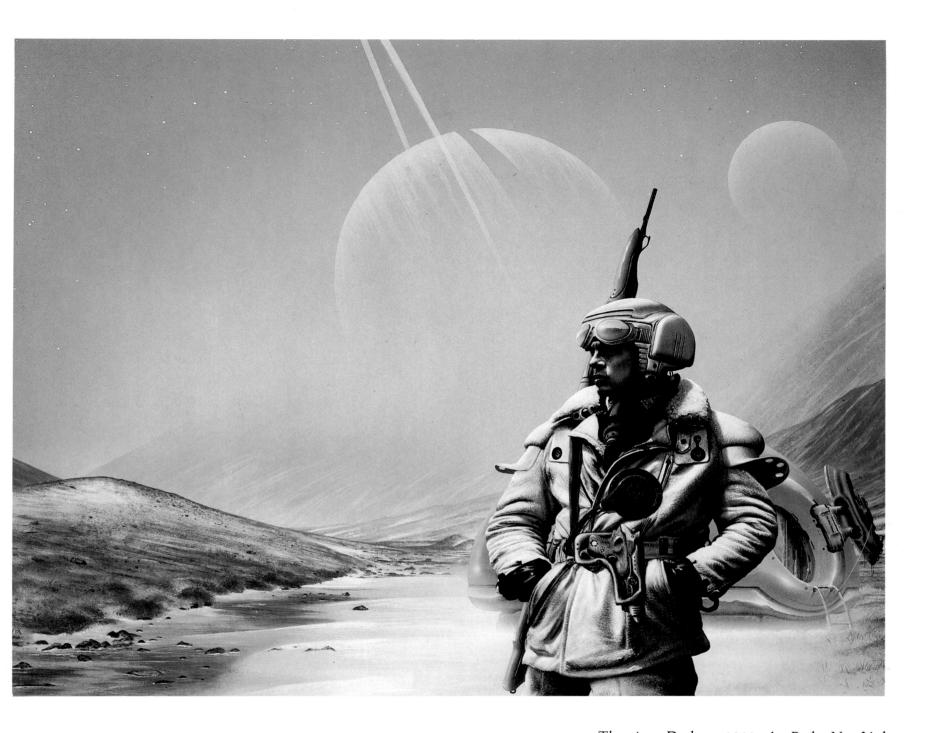

There is no Darkness 1982, Ace Books, New York

my original reference source. It's all trickery, really."

The humanoid alien, then, is another form of alter-ego to us whose symbolism dovetails with that of the android. But it's not exactly equivalent, for where the onlooker may identify directly with the android, he rarely does so with the alien. Instead he sees someone else, someone familiar yet strange, and ultimately unfathomable. Aliens tend to remind us that in the end we are all locked inside our skulls, peering out at the world but forever uncertain whether we really know or fully understand those around us. In this respect, the humanoid alien is every other person who is not ourselves.

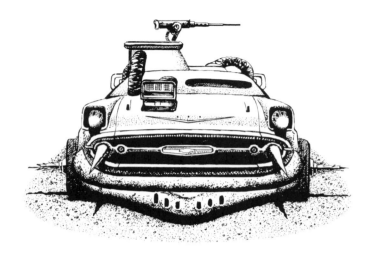

THE LAND IRONCLADS

The car has such a special place in our society that it deserves a chapter of its own. So familiar is it to all of us that we tend to take it for granted and ignore its complex and multi-valued symbolism. It is vital to many people in both practical and psychological senses.

The car is most commonly seen as a symbol of virility, and we've all encountered the souped-up red sports job driven noisily and at speed by men who use it as an expression of their masculinity. Not for nothing do we speak of sexual drives or talk of "she" going beautifully. A modern book on dream symbolism remarks that the car, the motorbike and the aeroplane are increasingly replacing the horse in dreams as symbols of energy and sexual virility. It doesn't say whether this applies to women as well as men, and it would be interesting to know. Women tend to use cars far more rationally and

realistically simply as transport, while men invest them with all sorts of obsessive qualities.

It's difficult to overstate the special importance of the car to modern civilization, the way in which it has transformed society in most countries of the world. In the twentieth century the fruits of the industrial revolution have gradually become available to a greater number of ordinary people. In developed countries at least our homes have filled up with a variety of gadgets from vacuum cleaners to televisions. But these forms of technology all act passively on our behalf. They are robots in the most limited sense of the word, performing a narrow range of functions which require only minimal human intervention.

Things are different with the car. We can get inside it and make it do what we want, instantly and on a whim. In

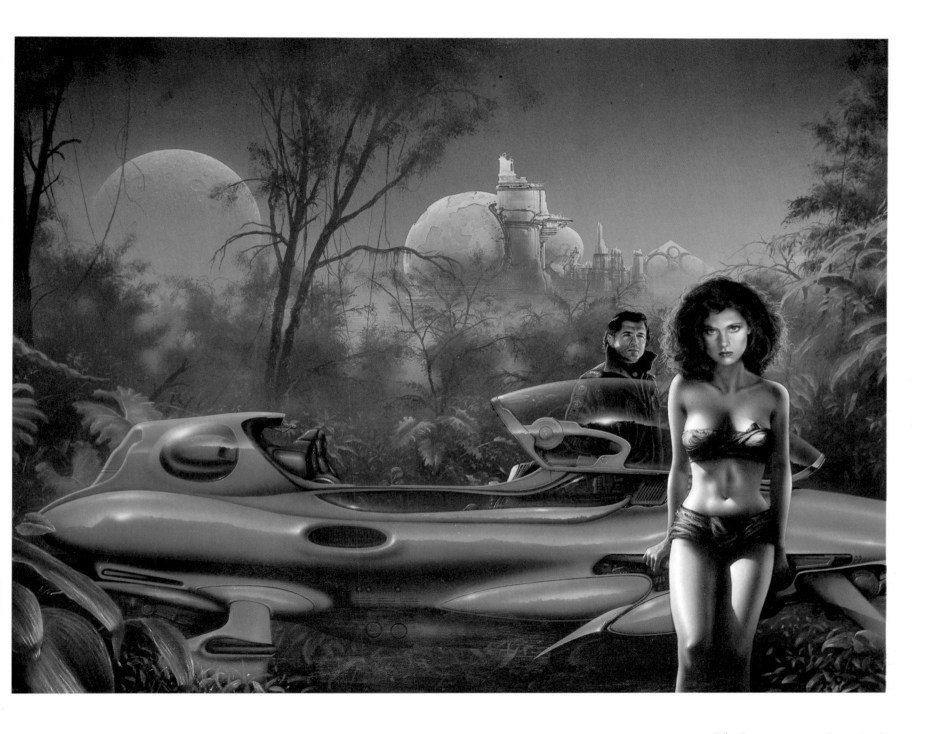

The Lovers 1981, Corgi Books

fact it forces us to control it constantly. It also wraps us in its shell, seals us off from the rest of the world and so enhances the feeling that it has become an extension of ourselves. It makes us stronger, faster, altogether more powerful while being a suit of armour that protects. For these reasons alone it's easy to see in retrospect that the

car was bound to win our favour. It's more personal and amenable to individual human control than any other form of technology widely available to people in this century. In modern computer parlance, it was the first really user-friendly technology.

Cars do more than simply make us faster and more

mobile — they also influence our behaviour. Another familiar figure is the timid man who, once he gets inside his car, becomes aggressive and self-assertive towards all other drivers. Being bigger, faster and stronger in a car allows people to express feelings which they might otherwise keep hidden. As a result, we often perceive other drivers as threats, and they're frequently portrayed in fantasy literature, movies and art in such a way. The success of the *Mad Max* films owes something to the use of the car as aggressor; they become festooned with gun cockpits, with battering rams, with lights that dazzle and blind. They look sinister even when they're stationary.

Trucks, tanks and similar vehicles are often cars made more massive and dangerous in this respect, and the Steven Spielberg film, *Duel*, is a classic treatment of "road paranoia", of the vehicle as "mean machine". The driver of the truck which haunts and attacks the hapless motorist throughout the film is never fully seen, and it's the truck itself which is perceived as the enemy. Standing under a dark tunnel, its headlights suddenly blaze on, and it becomes like a predatory animal about to pounce on its prey. More recently, in Stephen King's novel, *Christine*, the car of the title becomes demonic, possessed by evil forces and intent on destroying anyone who threatens it. It acts like a jealous lover, a modern embodiment of the phrase "Hell hath no fury like a woman scorned".

Cars, then, are symbols of personal power but also of threat. They are magic carpets which can take us to other lands or mad machines which can kill us. The thrill of travelling at high speed on a motorway is always tempered by fear — fear of a tyre bursting, of losing control of the steering, of other cars and their

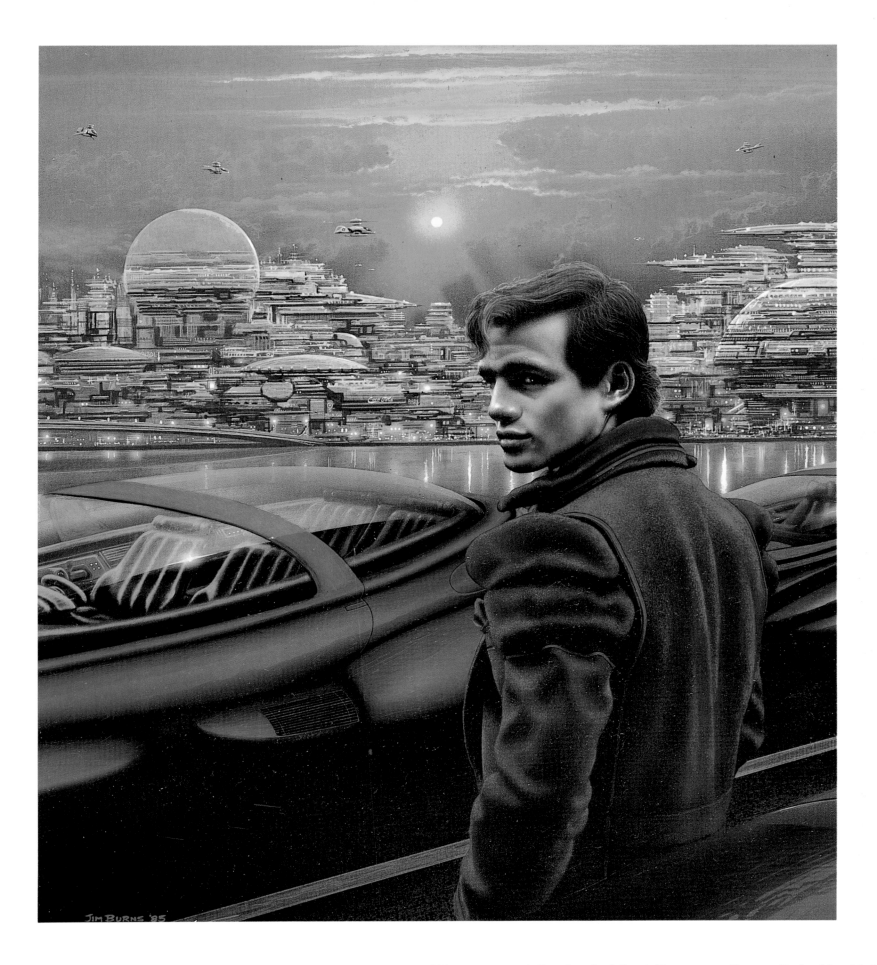

A Stainless Steel Rat is Born 1985, Bantam Books, New York

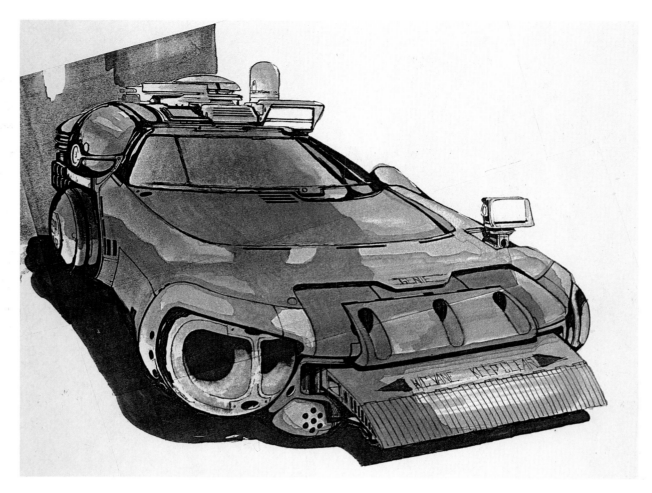

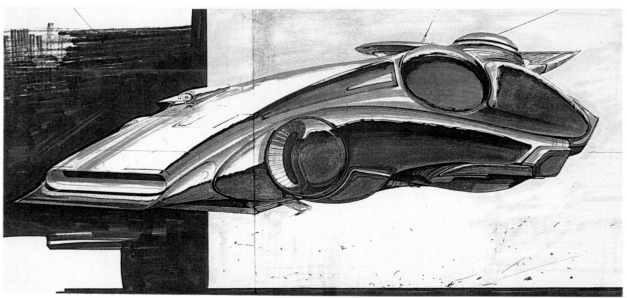

Bladerunner spinner 1980, Warner Brothers

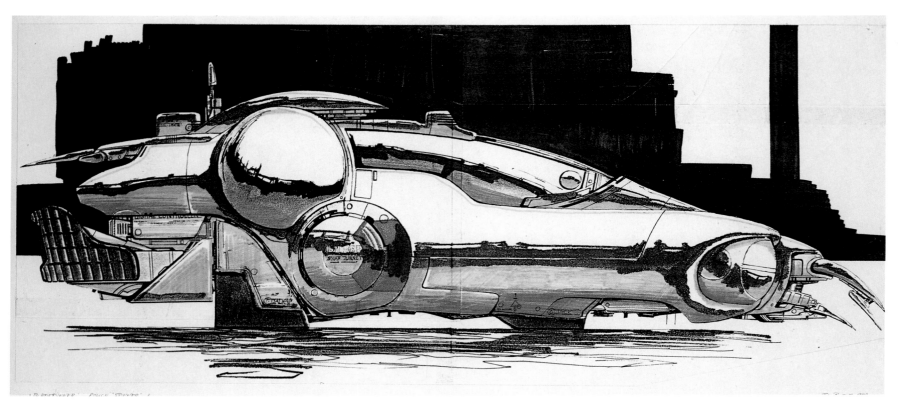

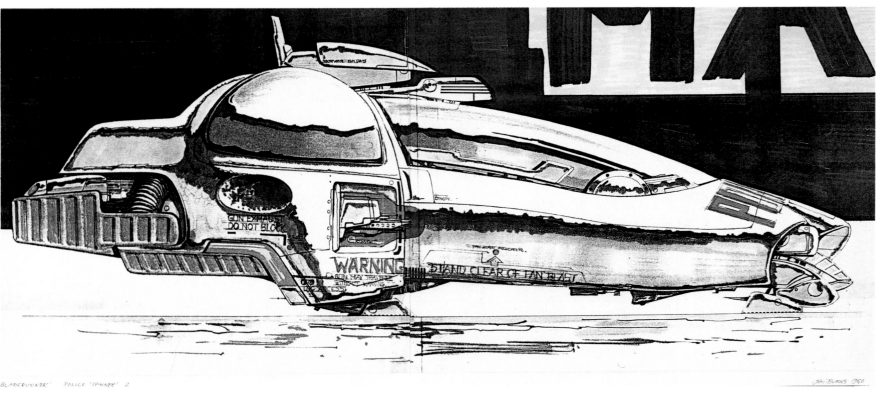

Bladerunner Spinner 1980, Warner Brothers

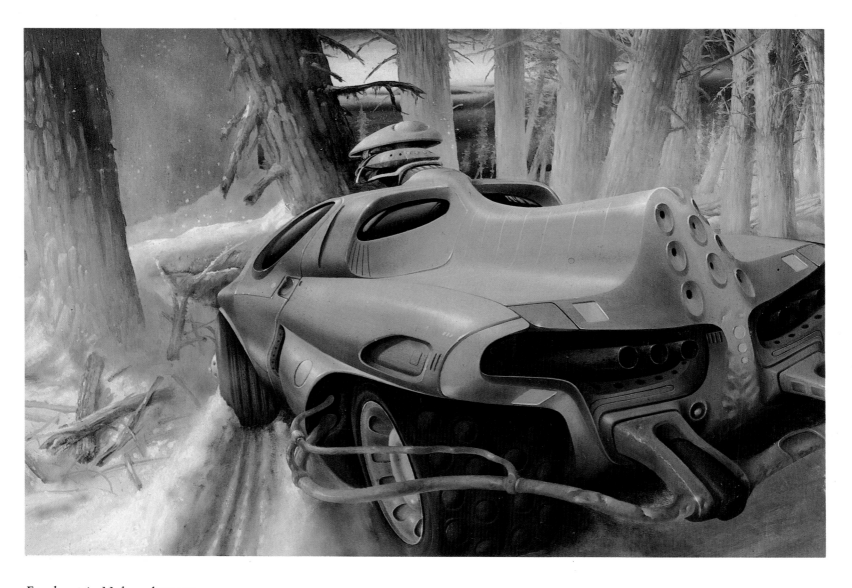

Frankenstein Unbound 1977

untrustworthy drivers. The multiple pile-up shows us the grisly consequences of the car as deathtrap, and J.G. Ballard has written a profoundly disturbing novel, *Crash*, which explores his character's obsession with motorway accidents and links such an obsession quite specifically with sexual desires.

The car as sex-object is seen more comfortingly at motor-shows, with gleaming new models surrounded by suitably alluring salesgirls inviting us to try them out. Jim Burns recognizes this connection in many of his illustrations of cars, their bright sinuous frames echoed by soft feminine contours of bare flesh. "I like to show cars as elegant products of human technology, as things which serve rather than threaten us. I'll adorn them with weaponry only if asked, my inclination being to encrust them with less aggressive paraphernalia."

It's hard to imagine a future without ground-based vehicles of some description, although the aircar beloved of science-fiction writers may eventually supersede the car if its conveniences and psychological comforts can be duplicated. No doubt there'll be customized models for drivers who really want to advertise their presence.

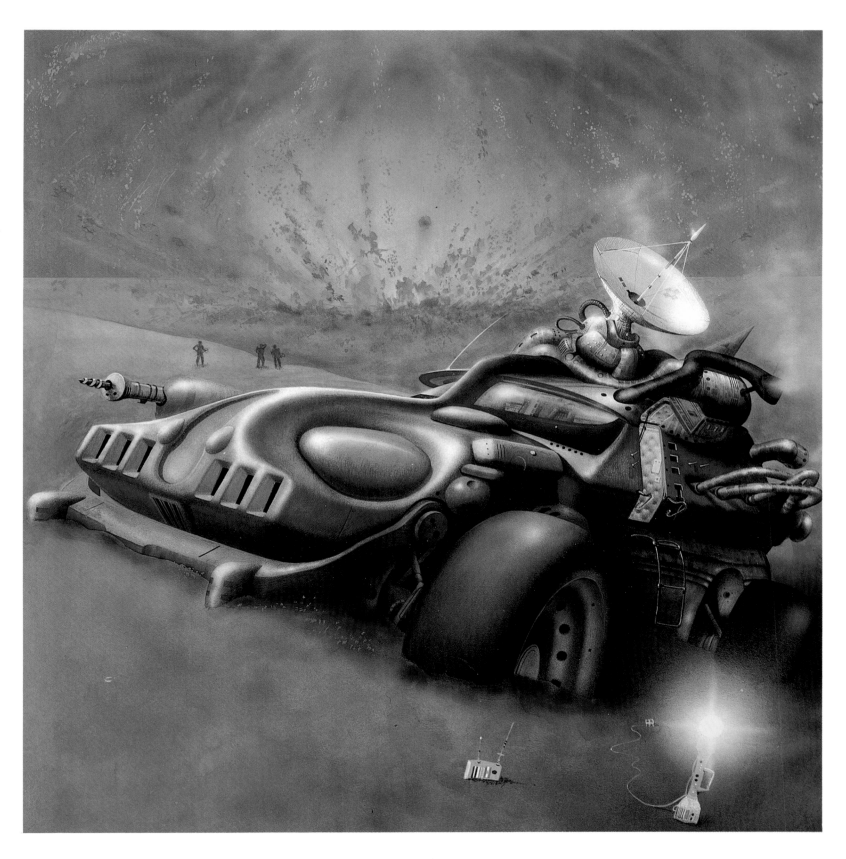

Mirror Image 1975, Sphere Books

P 76 Freeway Fighter 1984, Games Workshop

P 77 Battle Cars 1983, Games Workshop

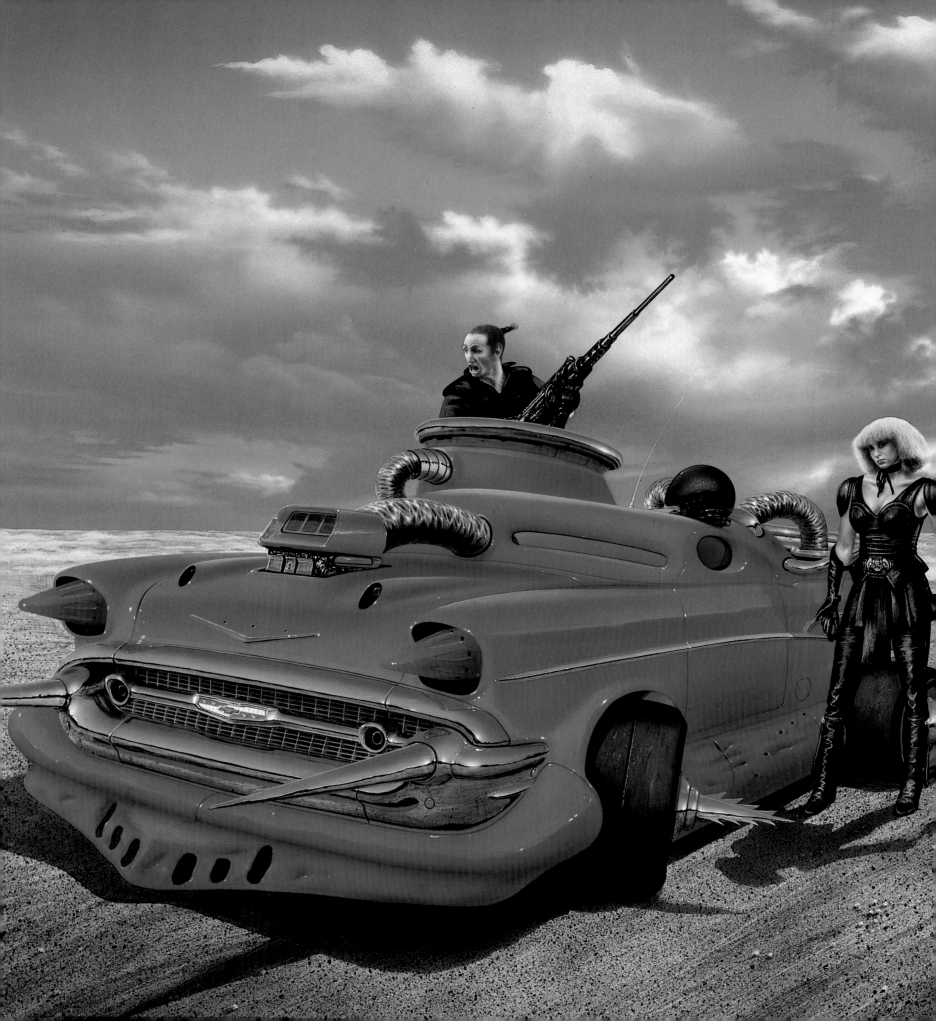

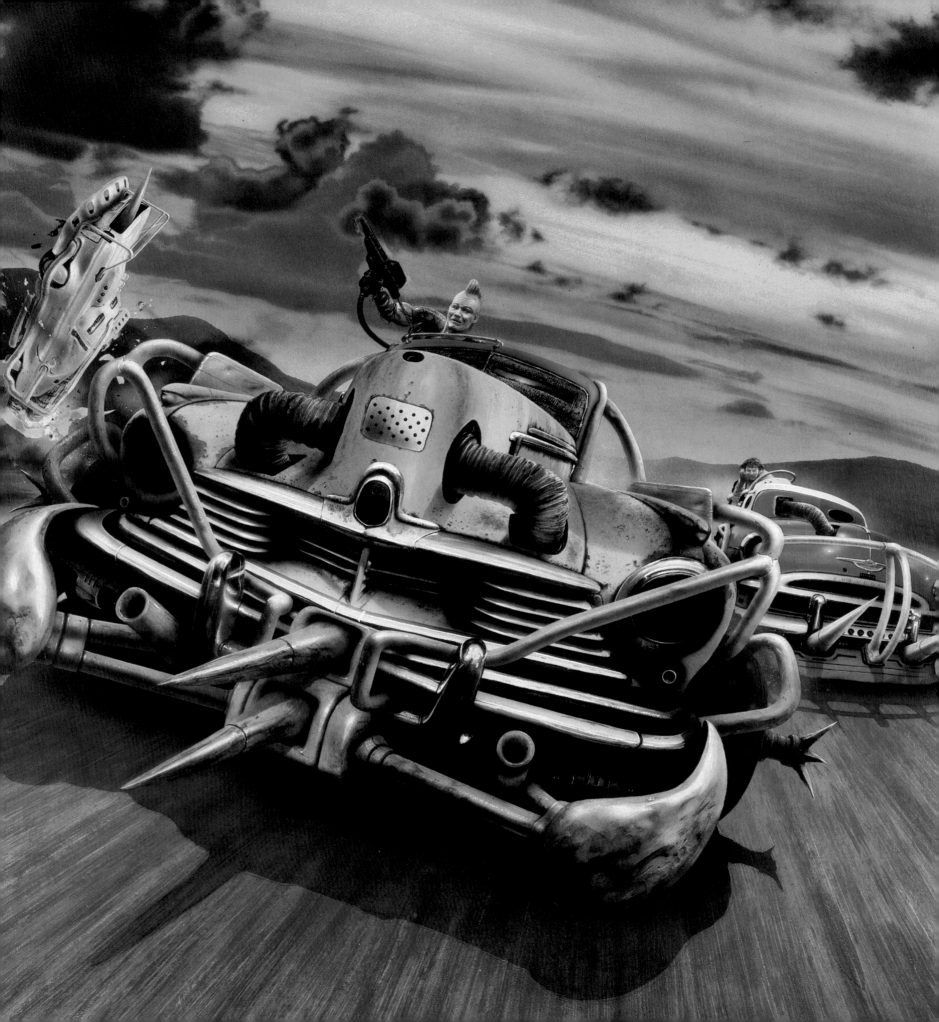

THE SPACE MACHINE

"I still think that the most fascinating 'spaceship' ever created was not the mothership from *Close Encounters* or George Pal's Martian invasion ships from *War of the Worlds* or any of the multitude of shapes filling the screen during *Star Wars*. Nor was it any of the vehicles conjured up by a host of artists during the last half century. It was a real one — the spider-like Lunar Excursion Module of 1969 vintage. Who'd ever have thought that Man's first venture to another world would be in such a wonderful Heath Robinson contraption?"

Pick a dozen science-fiction paperbacks from a book shelf, and there's a good chance that well over half of them will have a spacecraft somewhere on their covers. The starship, formerly the rocket, is the quintessential science-fiction image, particularly as far as illustrators are concerned. We're always seeing it ploughing through the depths of space or framed against a dramatic planetary landscape or standing sentinel on some newly visited world. It needs to be a stirring sight because it embodies so many of the hopes of those of us who look to the future.

Space is vast beyond human imagining. Light from the Sun takes roughly eight minutes to reach Earth, and five-and-a-half hours to reach Pluto, the outermost known planet of our Solar System. But to travel to the nearest star even at the speed of light would take over four years, and to cross the galaxy of stars of which the Sun is a part would take a hundred thousand years. And beyond that, lie millions of other galaxies, stretching to the edges of the

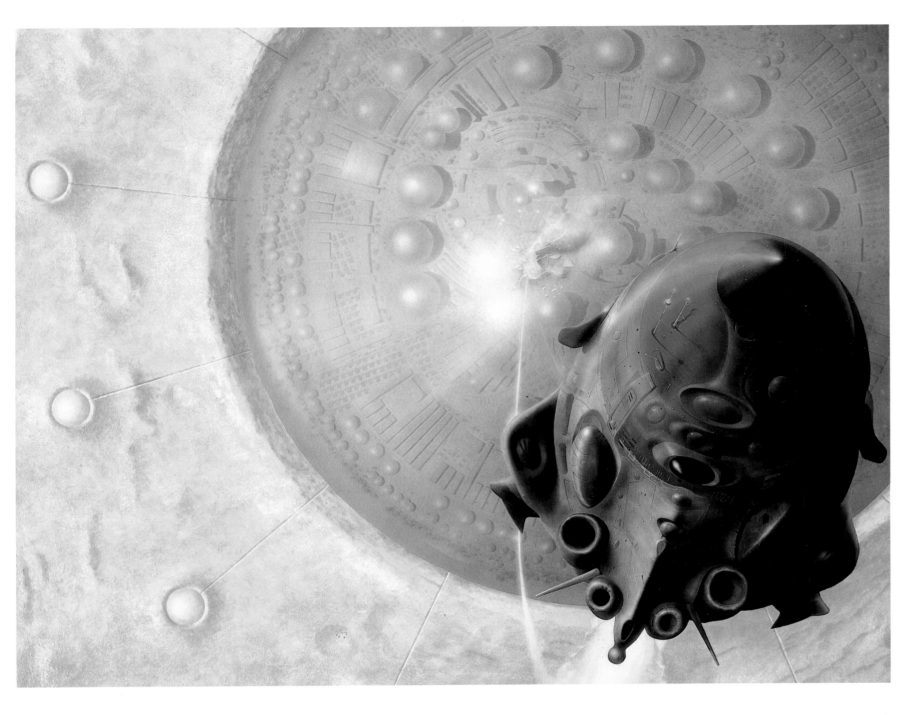

The Seed of Light 1977, Coronet Books

universe, almost infinitely distant.

Modern science places the speed of light as an upper limit on how fast an object can travel, and this poses problems if we wish to explore the universe, or even our own galaxy. Using today's technologies, our spacecraft would be hopelessly inadequate for the task. It would be like an ant trying to cross the Atlantic on a blade of grass.

But science-fiction is an ingenious literature, and its writers have found ways around this restriction, as we'll see.

Spacecraft based on technically feasible propulsion systems take several different forms. Rocket-power, involving the chemical combustion of fuels stored as liquids, has already carried men to the Moon, but it's not

practical for much longer voyages. The next stage may well be nuclear-powered ships, one idea being that pulsed fusion-bomb explosions could be controlled and directed to propel the ship forward. Another possibility is the ion-drive, involving the acceleration of charged particles by an electric field. Ships with enormous sails driven by the pressure of starlight have also been contemplated, as has the ramscoop, which would suck thinly dispersed hydrogen from interstellar space through an enormous gaping magnetic "mouth" and might look like a shuttlecock flying broad-end forwards. Some of these ships will probably never be built.

Science-fiction writers who have accepted the limitation of the speed of light on space-travel often invoke the idea of "suspended animation", which puts a crew into a deep sleep with their bodily processes frozen for the duration of a long voyage through space; they are awakened when they arrive at their destination. Or there's the "generation" starship, in which space voyages lasting centuries or millenia are completed by the descendants of the original crew, children being born and raised on board the ship and undergoing training which allows them to take over its running when they reach adulthood. In such cases the ship will grow its own food, generate its own air, and effectively become an artificial world.

For ships travelling close to the speed of light, time actually slows down relative to Earth — a bizarre but real consquence of the Theory of Relativity. As a result, it is in fact possible to cover immense distances in the course of a human lifetime aboard the starship while thousands of years may have passed on Earth. These are all ways in which we may be able partially to overcome the problems of the universe's unimaginable size. But in science-fiction, a literature impatient for the future, swifter means have been developed of circumventing the problem, the most popular of which is the notion of warp-space.

The usual analogy invoked here is that of two points on a sheet of paper. The shortest distance between the points is a straight line. But if the paper is folded over so that the

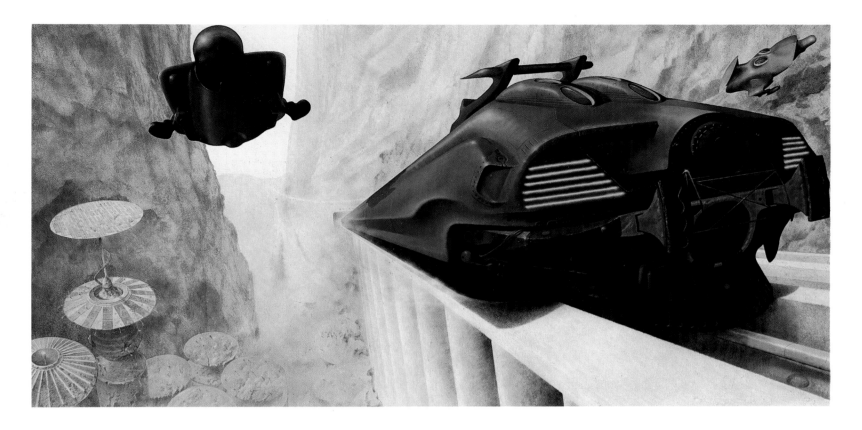

two points sit exactly against one another, then the distance is reduced to zero. Warp-space is the three-dimensional equivalent of folding paper so that distance is no object. Starships can jump across the vast gulfs of space in seconds.

Science has yet to make the idea of warp-space respectable, though it hasn't been entirely ruled out as impossible. Emotionally and imaginatively we need something of this sort to make the universe accessible to us. Meanwhile fictional spacecraft have been taking us to far distant planets and galaxies for decades.

Dick Calkins, the artist on the Buck Rogers comic strip (which began in 1929) is generally credited with influencing the design of early fictional spacecraft, showing them as cylinders with rounded noses, portholes and streamlined sharks'-fin wings. This basic shape was adopted by many pulp artists in the 1930s. Their space-ships tended to look like flying torpedoes, submarines and contemporary aircraft with shrunken wings or none at all. Some even bear a resemblance to today's high-speed trains.

Sub-orbital craft, meanwhile, which were restricted to the Earth's atmosphere, were frequently modelled on dirigibles and smaller aeroplanes, often with helicopter rotors added. The helicopter remains a favourite prototype for such craft, though pod-shaped vehicles which recall space capsules and satellites have also been popular, even up to the present. Often spaceships are assumed to be able to fly in space and in air so that the two kinds of craft become one, as with the shuttle in real life.

The Second World War brought the science of rocketry alive in the most direct and threatening manner with the German V-1 and V-2 flying bombs. These gave us our still-familiar image of the rocket as missile-shaped, with a cluster of fins around its base. This design was widely adopted, some artists even using it for depictions of buildings in their awesome future cities.

In the post-war period, jet aeroplanes became common, and the rocket acquired wings and tail fins just like them. Spacecraft of this period look highly streamlined, their

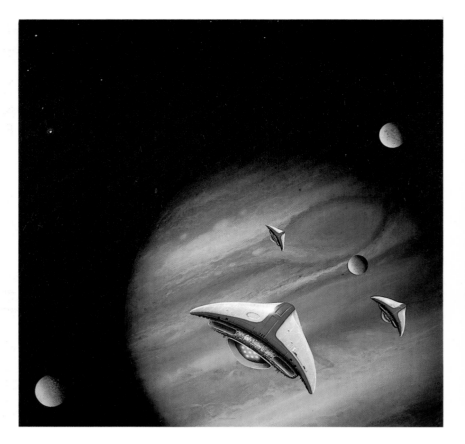

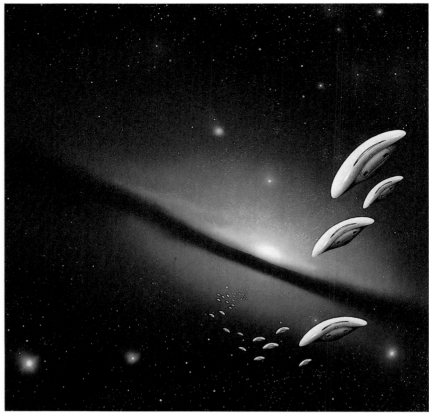

Galactic Invasion 1982, ICL Software

Invasion from Jupiter 1982, ICL Software
Star Trail 1982, ICL Software

pointed noses thrusting proudly towards the stars as they rise on pillars of fire. Saucer-shaped craft also became common at the same time, inspired by the UFO craze which began with the coining of the term "flying saucer" in 1947. Both these designs of spacecraft remain popular today, especially in video games and science-fiction cartoons.

The post-war period was a fertile time for spacecraft design. Some artists were beginning to take into account the fact that space was a vacuum with no air-resistance and hence no need for aerodynamic designs in ships travelling between planets and moons at the speeds then envisaged. At the same time nuclear power was enjoying a vogue as an energy source, and particularly as a source of spacecraft propulsion. But nuclear reactors were

Marune 1978, Coronet Books

The Stochastic Man 1977, Coronet Books

dangerous, and would therefore have to be well separated from the living quarters of the ship.

Both these influences had combined by the early 1950s to produce an alternative image of the spaceship in which the flight-deck sat on top of a skeletal metal framework enclosing a cluster of cylindrical fuel tanks with the nuclear reactor at the base. This type of design, now fallen out of favour with artists, has recently been revived as a technologically feasible starship which could be accelerated gradually to velocities necessary to carry it to other star-systems.

In the 1960s, though, spaceships continued to look more like missiles and jet aircraft than anything else, many echoing the designs of American and Soviet launchers which had become science fact. Wheel-like space stations were also popular, and the Stanley Kubrick film, *2001: A Space Odyssey*, introduced a spaceship which looked like a barbell, with the engines and living quarters at either end of long connecting struts.

Then, in the 1970s, a new breed of spacecraft appeared — massive monolithic starships which are majestic products of advanced technologies. The British artist Chris Foss is generally credited with establishing a vogue for such ships, and he spawned many imitators. Foss's spaceships are angular, asymmetrical, brightly chequered or striped, with a weathered look which contrasts with the gleaming darts and saucers that preceded them. But above all they are huge and awesome, framed by sweeping planetscapes or swathes of space which convey a sense of the immensity of the universe.

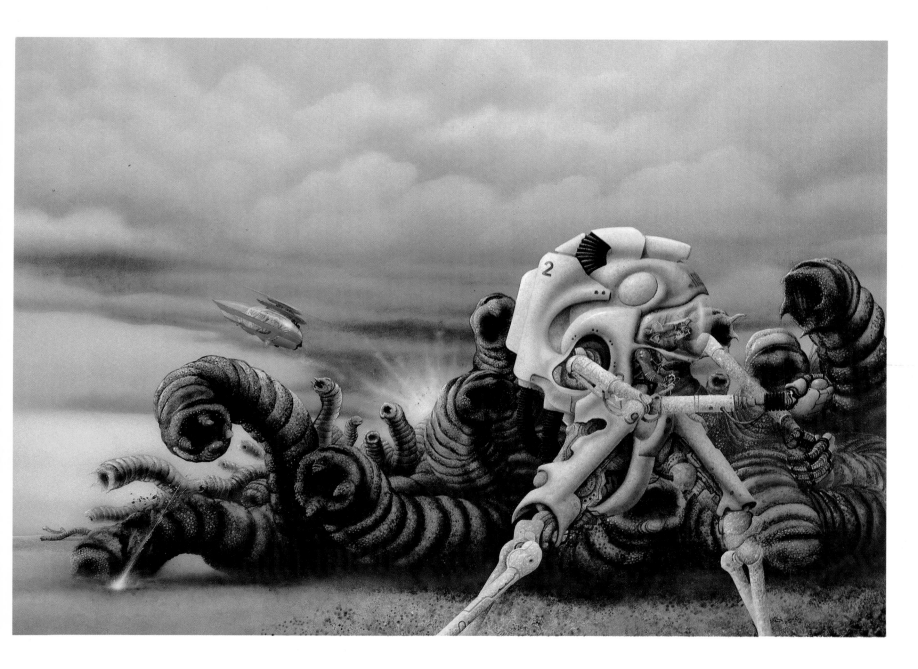

The Deathworms of Kratos 1979, Coronet Books

This impression of scale made them effective above all else, and other artists also began to portray similar craft which were big enough to be mini-worlds themselves and were not dwarfed by the great empty spaces between worlds. Humans were often absent from such pictures or relegated to tiny figures peering through portholes.

It's been said that these kind of illustrations lack a human dimension, but that is to take a superficial view. The ships were often playfully designed and were almost always brightly painted with stripes or spots or futuristic emblems which are mostly decoration just for the sake of it. They advertise their presence with ceremonial colour — a very human indulgence. What they argue most is that the universe can be made accessible to us only if we have the grandeur and the cheek to build on a monumental scale.

This new breed of spaceships, impressive though they were and are, tend to be very much in the modernist style which exalts technology and functionalism. They are things of metal and bristling communications antenna, of

P86/87 Mechanismo (Cover) 1978, Pierrot Publishing

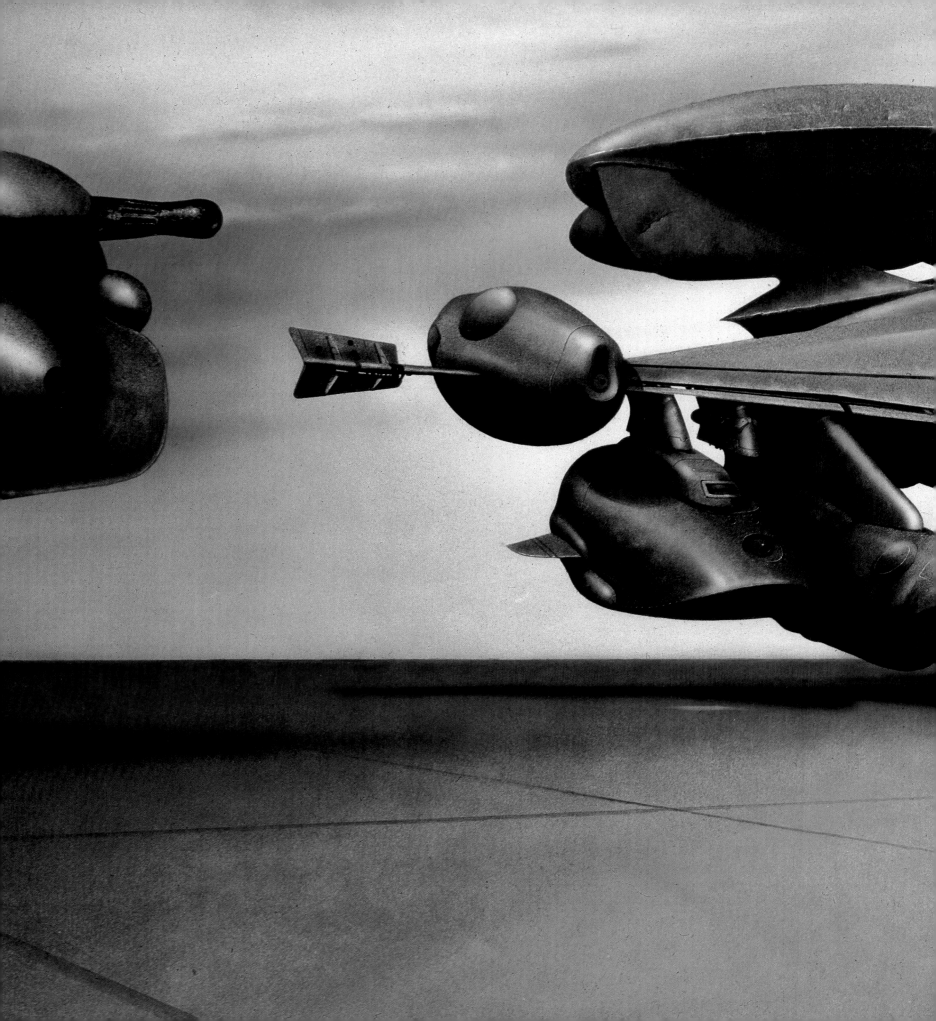

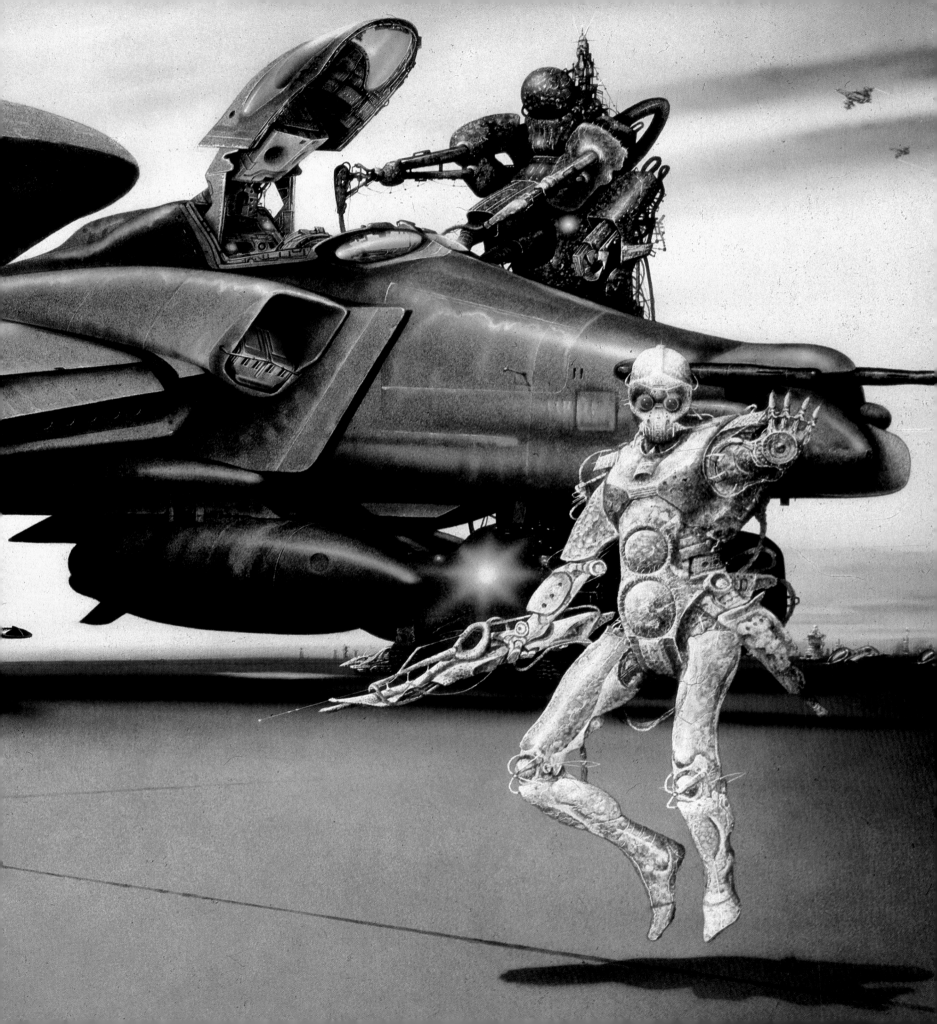

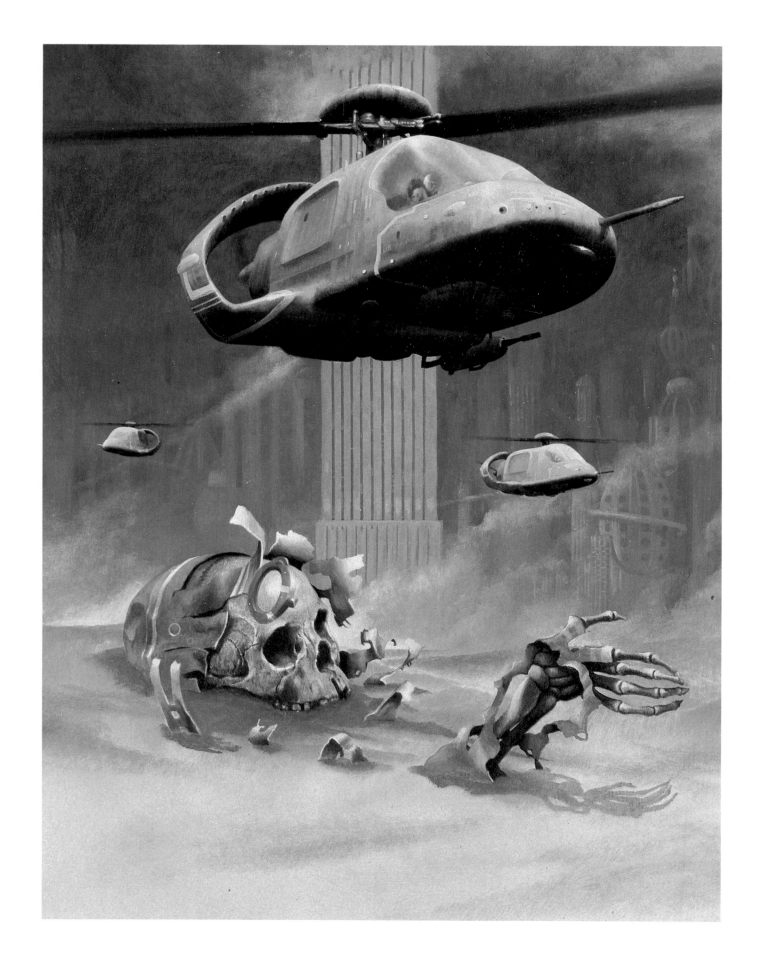

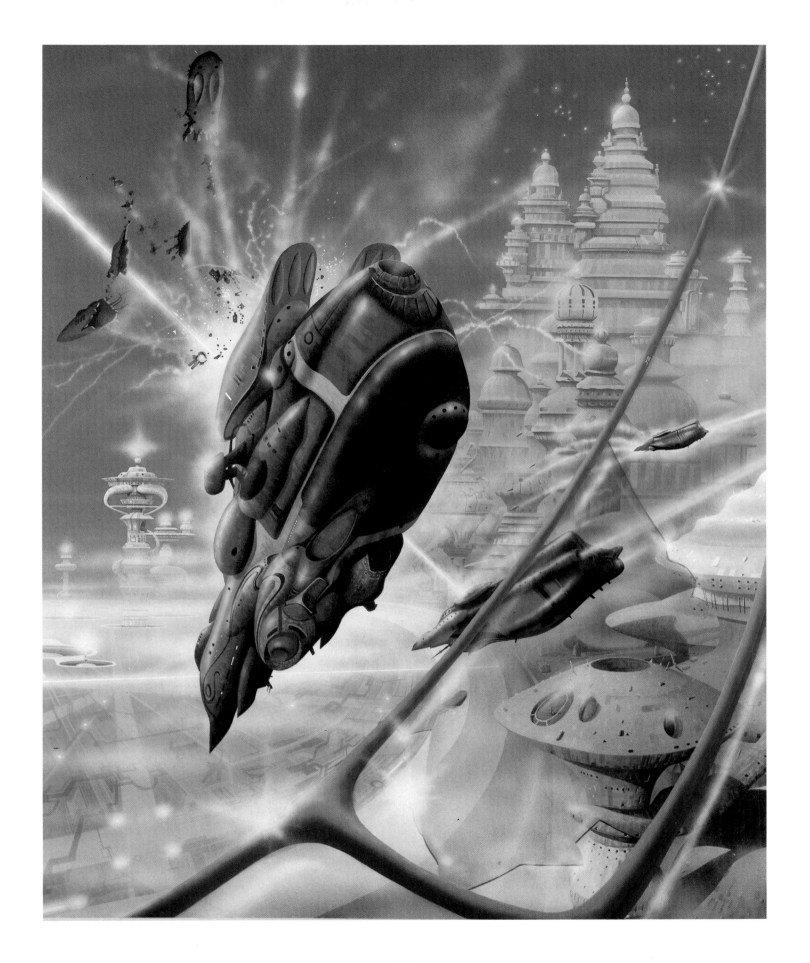

The Long Way Home 1975, Panther Books

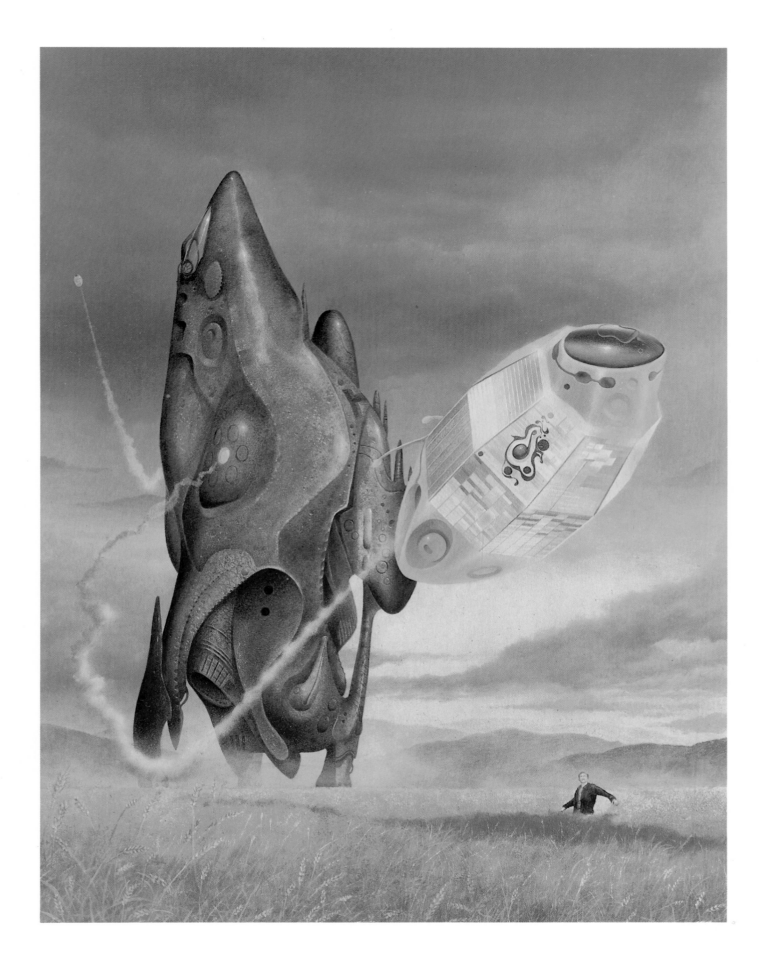

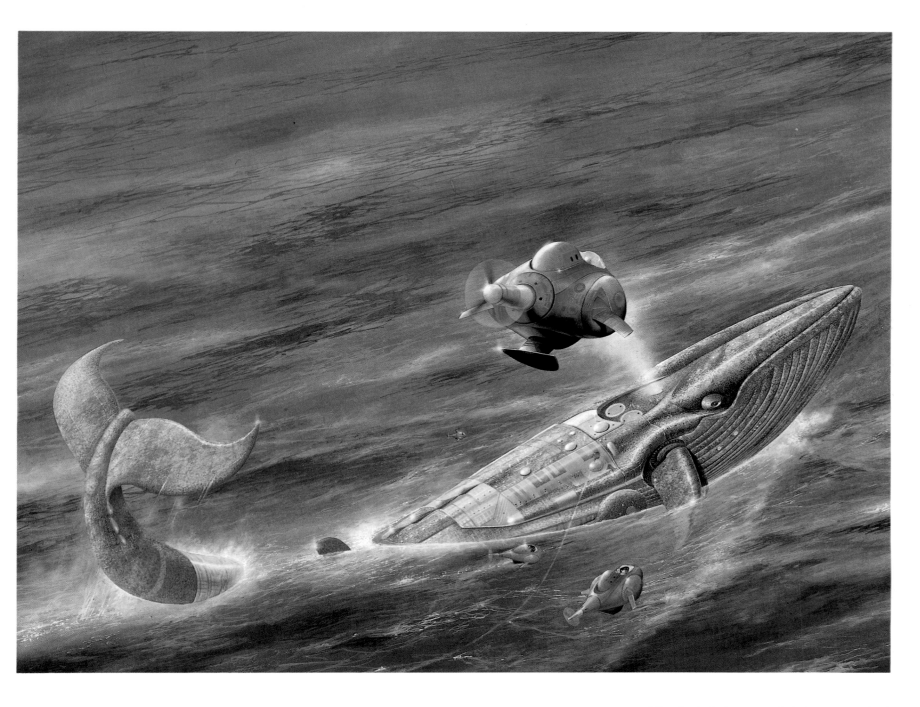

The Godwhale 1976, Methuen Paperbacks

hard, cold, flat surfaces. They reflect the rectilinear thinking which has dominated post-war design and is most obviously seen in our buildings with their blocks of concrete, sheets of plate glass, girders of steel. Ornamentation, as opposed to decoration, has been banished, and everything is hard-angled corners and metal panelling.

Recently a reaction has begun to set in against such planar, utilitarian shapes, and Jim Burns was one of the first to reflect our increasing desire for designs in which curves and flourishes have their place. His spacecraft have a much more rounded appearance and often an organic look to them. They are bulging, sinuous things, with plenty of ornate trappings. They may be ships of metal, but equally often they look as if they've been hewn from stone or moulded from plastic-like materials. Burns

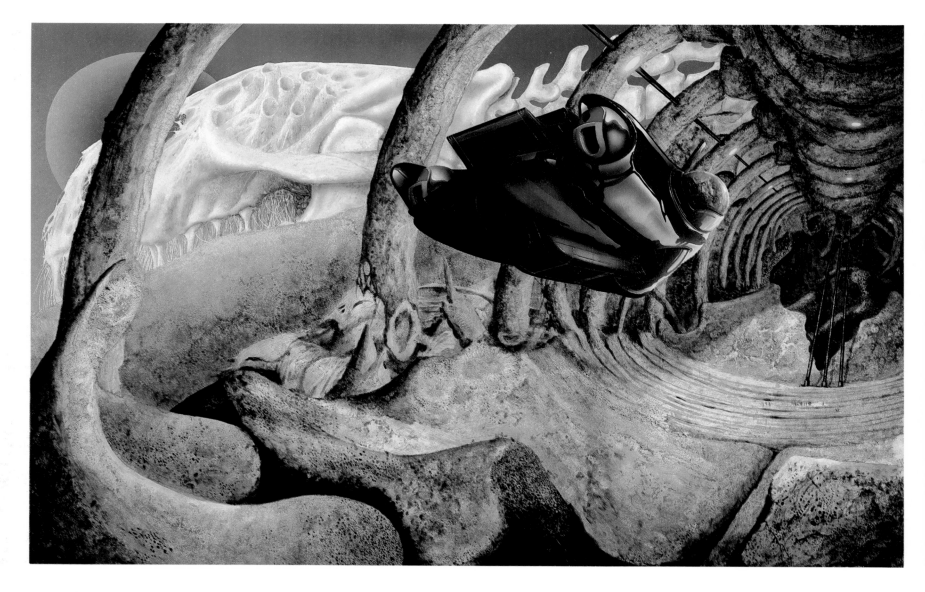

Tour of the Universe – Behemoth 1980, Pierrot

favours such shapes not just for artistic reasons or simply out of wish-fulfillment.

"How a craft should look will depend on all sorts of obscure rationales, and I'm sure that a variety of emerging criteria will push towards the exotic the design of future spacecraft. If you study even today the 'neo-baroque' form of, say, an Apache helicopter, built like an aerial tank and plastered with the ghastly appendages of modern warfare, then it's possible to see how rashly one makes assumptions about the design of futuristic craft."

Burns does, however, strive to make his craft look as if they have been *designed* by intelligent beings. "It's really too easy for an illustrator to chuck together a heap of very arbitrary shapes and colours, make it 'big' by the judicious use of illustrative 'devices', and call it a starship. All right, the mind behind it may be supposed to be alien; it might be put together more by instinctive design like a bee's honeycomb or a termite hill rather than with blueprints or computer-aided graphics. It might be made of the most unlikely of substances. Perhaps gold or silver or even diamond is absurdly common somewhere. But if a true sense of wonder is to be got across, then some discipline has to be employed in depicting the products of truly alien minds or perceptions."

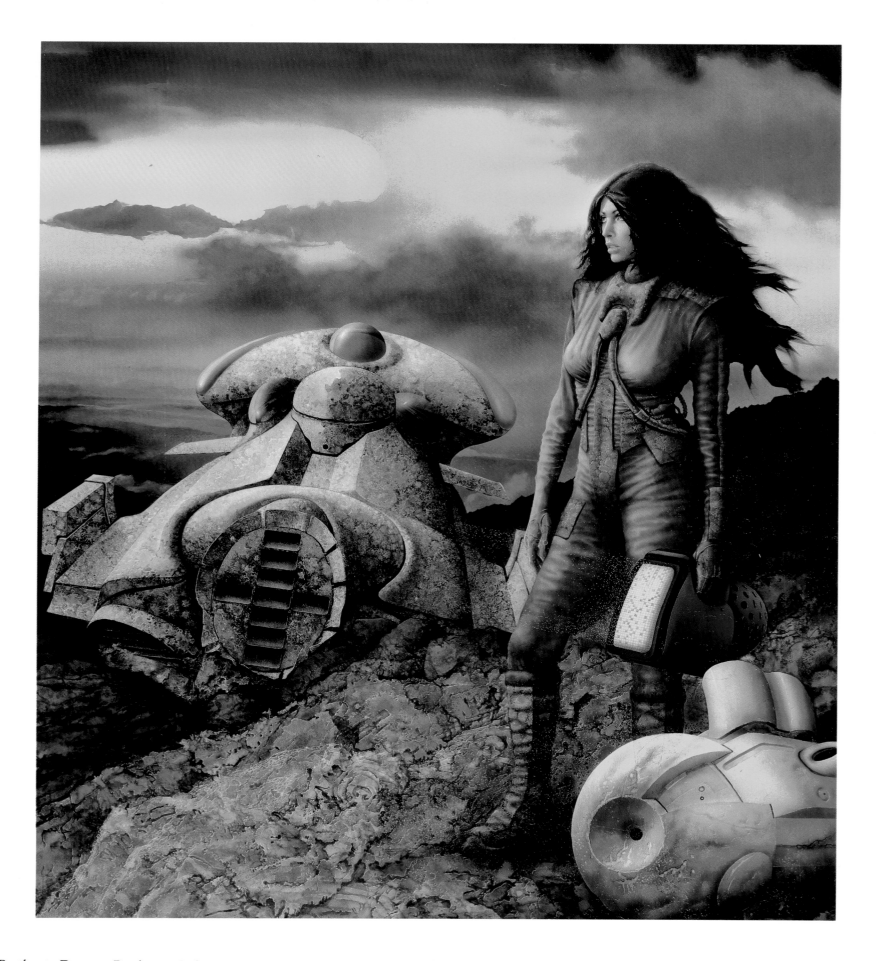

Brother to Demons, Brother to Gods 1980,

P 94/95 Durdane Trilogy 1974, Coronet Books

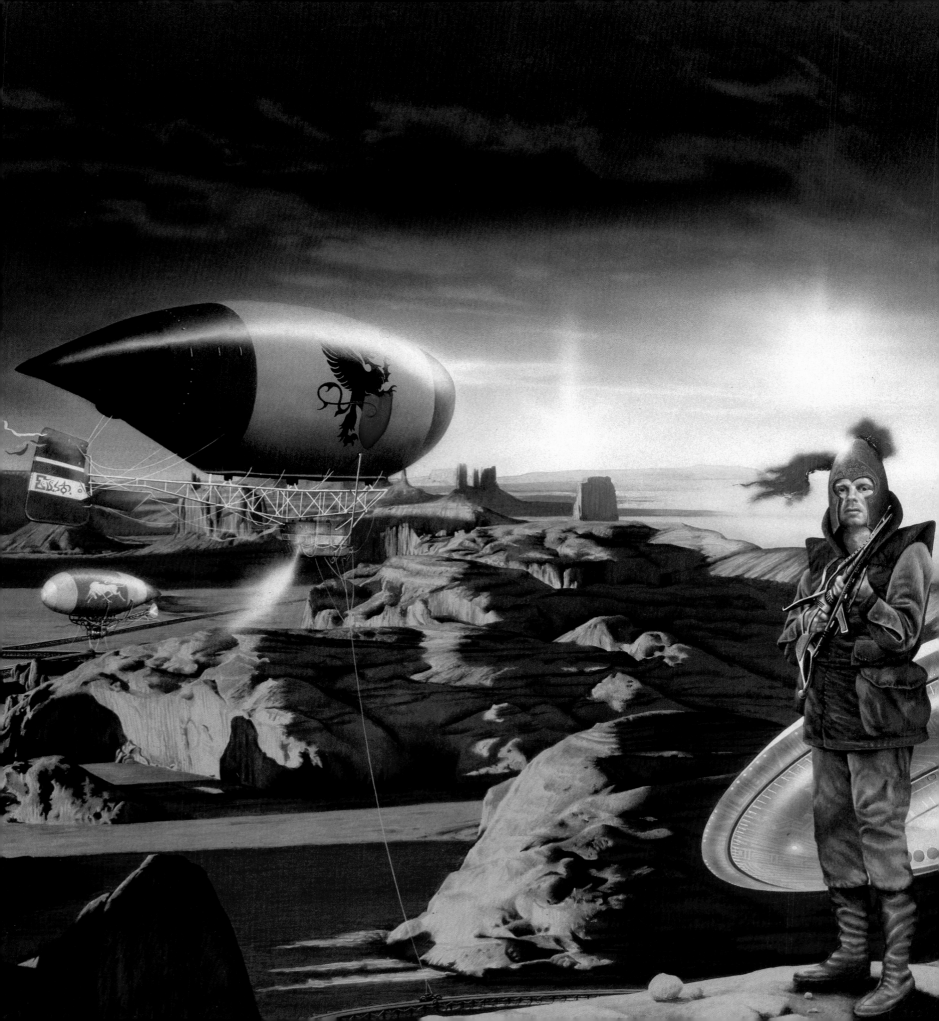

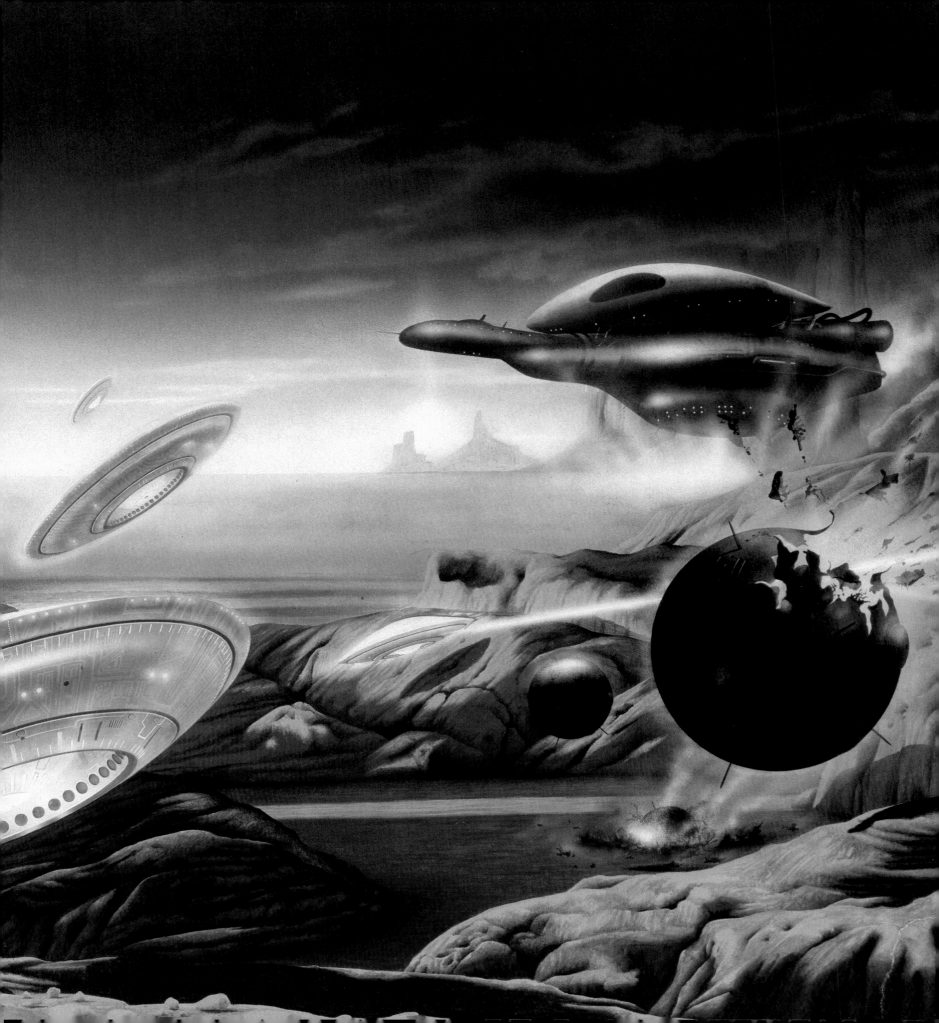

THE CITY
AND THE STARS

This chapter is concerned with what may loosely be called artificial habitations. If the starship is the symbol of humanity's outward urge to conquer the universe, so the city and its offspring could be seen as symbols of our mastery over nature on Earth. The worldship, an artificial environment in space designed to be self-supporting for a large population, blends the images of the city and the starship and becomes a means of taking the Earth into space with us — a comfortable way to travel.

Science-fiction is primarily an urban form of literature since it's the city whose inhabitants are always at the cutting-edge of technological and social change. New ideas and artifacts always appear there first; it's a melting-pot for dangerous visions and realities. It's also an environment designed to protect us against nature's

harshness. We began in caves, with spears and animal skins to defend us against hostile creatures and climates. Now we inhabit air-conditioned towers, shielded from wild animals and weather, surrounded by luxurious comforts and labour-saving devices. We've even managed to banish seasonal and day-night rhythms with central heating and artificial lighting.

Cities and spaceships are two sides of the same coin. From the earliest days of sophisticated architecture, buildings have been constructed with towers and spires, and no science-fiction metropolis is complete without them. The tower is a symbol of ascent which links earth with heaven, and the city of spires can therefore be seen as humanity beginning to look skywards now that it has finally established a solid platform on Earth. The

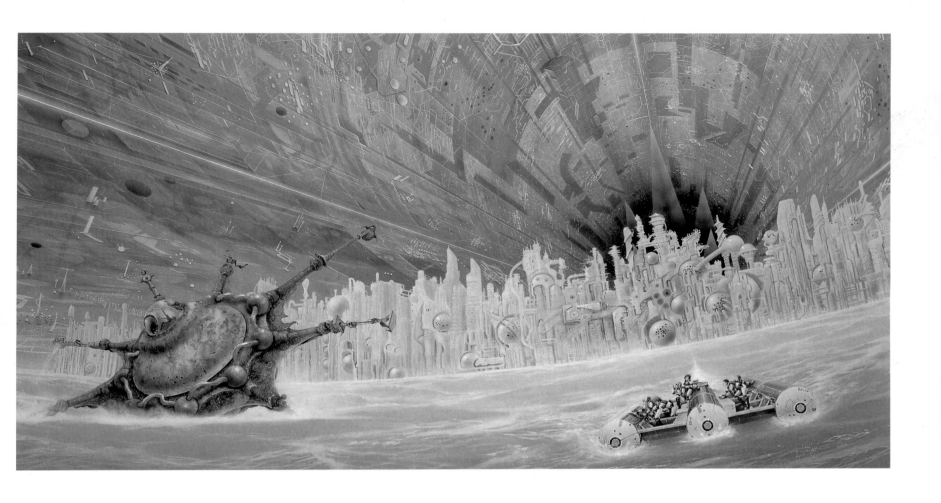

spaceship is the tower freed from the bonds of gravity which will actually take us there.

In earlier times our yearning for higher things was expressed religiously — the tallest buildings were cathedrals or domed temples. Our desire to transcend our planet remains primarily a spiritual one, and science-fictional buildings often resemble churches or mosques. They speak of glory but also of a need to escape. Cities may be noble things when seen as skyline panoramas, but penetrate to their hearts, to ground level, and you'll find all manner of filth and evil. They embody not only our highest aspirations but also our greatest failures.

Fritz Lang's 1926 film *Metropolis* established an early visual prototype of the future city — a place of enormous buildings and machines where humanity was dwarfed,

reduced to ant-like behaviour. Pulp magazine artists eagerly adapted the film's designs and atmosphere, especially retaining the sense of scale. Ranks of massive towers formed vast concrete chasms spanned by bridges and flyovers carrying the busy commuter traffic of the future to its working place. The pulp artists' cities tended to be more amenable to human beings than Lang's, reflecting the fact that genre science-fiction has always taken a double-edged view of the city as the natural home of humanity as well as its prison.

The buidings in these imagined cities attained a monumental size unmatched by any spacecraft of the day. They were modelled after existing skyscrapers or pyramids or electric pylons — all of these preserving a tapering rather than rectangular appearance. Fast-

moving traffic was usually a vital part of the scene, as if mobility was being used to counterbalance the density of towers which created the impression of hemming in its population. Later, buildings took on the globe-shapes of nuclear reactors, but they were invariably coupled with towers or put on stilts so that they became vertical in the grand tradition of their predecessors.

Cities were constantly looking to the heavens, and they were soon to take flight. First they were topped by transparent domes which completed the process of shutting out nature. From there it was a simple step to launch them into space. They were portrayed nestling under blisters at the centres of metal wheels, or in spheres whose bottom halves preserved the ground on which they stood, or on vast metal plates like exotic wedding cakes. And in James Blish's celebrated 1950s series *Cities in Flight* they are literally launched into space with their bedrock by means of anti-gravity devices.

It's unlikely that cities in their present form will ever take to the skies. But the idea of an artificial space environment which contains and supports its population has recently gained scientific respectability and resurrects the idea of a wheel — or, more accurately, a doughnut-shaped space station inside which an environment resembling Earth's could be re-created.

Gerald K. O'Neill, an American physicist, popularized this idea in his 1977 book, *The High Frontier*. Up to this time, space stations in orbit around the Earth had been imagined as floating laboratories or stopping-off points for spacecraft rather than settlements; but O'Neill's idea was to make use of the cheap energy available in space to construct permanent habitats in stable orbits which would support a city-sized population. Inside the circular cylinder of the wheel, raw materials mined cheaply from the Moon or the asteroids could be used to create a landscape with earth, grass, trees, water and air in which humans could live. Solar energy would be available 24 hours a day to power the habitat, which would spin on its

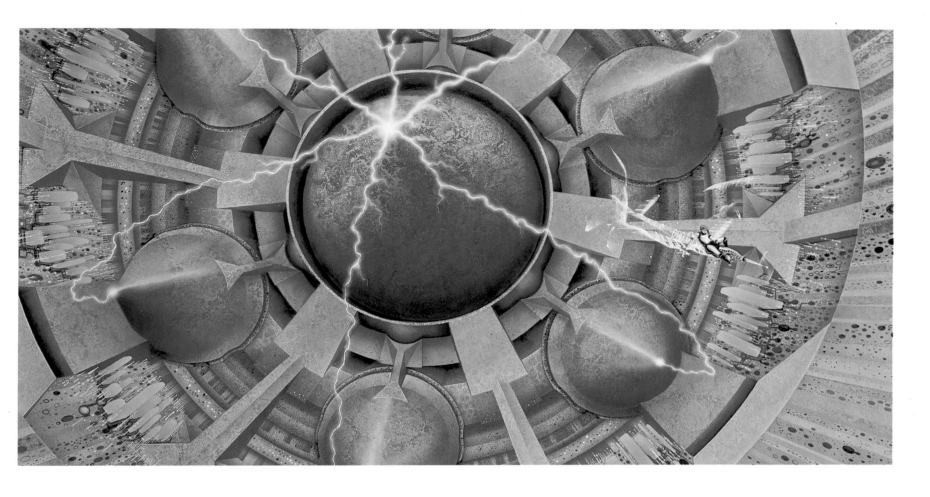

Alien Landscapes – Rendezvous with Rama 1 (Spike Power) 1979, Pierrot Publishing

axis to generate an Earth-type gravity. With such an abundant energy supply, the colony could grow its own food, produce its own manufactured goods and become self-sustaining.

O'Neill takes the view that other planets are not cost-effective in energy terms to be converted into Earth-like worlds for colonization. It's therefore easier to construct the kind of environment we want from scratch in space. And once such an environment is built, there's no sense in sending it off into deep space; better that it remains close to Earth and reaps all the energy benefits of constant sunshine and readily accessible raw materials from low-gravity worlds like the Moon.

This may make practical sense, but our dreams always carry us further than practicalities. The human race will undoubtedly wish to explore the deeper reaches of space if it manages to avoid annihilating itself here on Earth. We may indeed build ships like artificial worlds to contain us as we travel outwards. But travel outwards we will.

Meanwhile other civilizations in the cosmos, if they exist, may be doing the same, and scienc-fiction is filled with tales of alien relics in space. Arthur C. Clarke's 1973 novel *Rendezvous with Rama* tells of a massive extrater-restrial artifact (the Rama of the title) which enters the Solar System unannounced in the near future and is explored by humans who manage to penetrate it. Rama is a cylinder fifty kilometres long and twenty in diameter which rotates on its axis, generating an artificial gravity which allows the humans to explore the strange environment they find inside — a world of city-like structures, seas and animal-like creatures who also resemble machines. Intelligent aliens are not, in fact, found inside the artifact, but the novel successfully conveys the enigmatic qualities of its alien origin.

Other s-f writers have described artificial worlds on even grander scales. In 1970 the American writer Larry Niven published *Ringworld*, a novel about the discovery of an artifical ring built around a sun and designed for

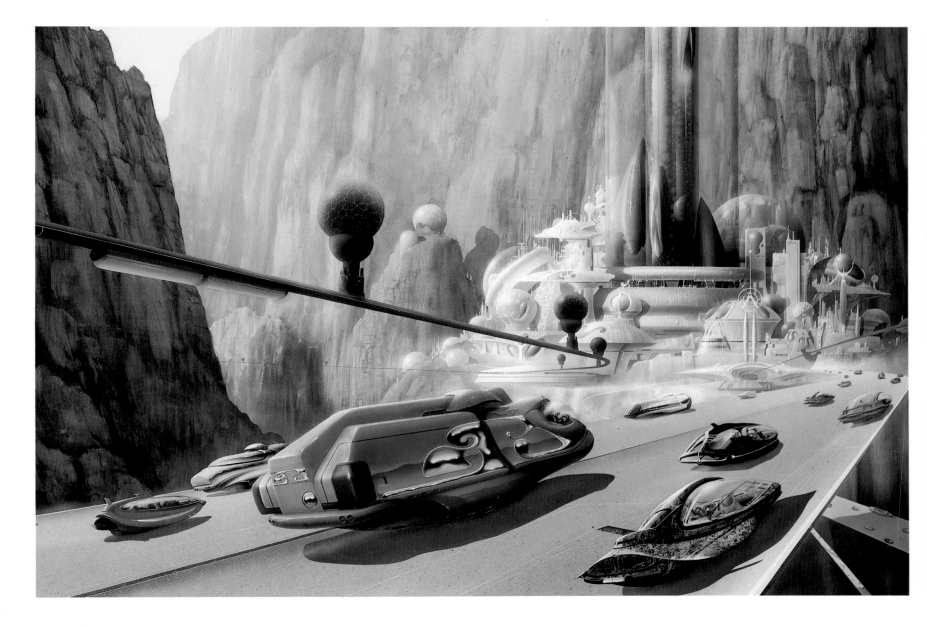

Tour of the Universe – Earthport 1980, Pierrot

habitation. Five years later the British writer Bob Shaw described in *Orbitsville* a Dyson sphere — a habitable shell which completely surrounds a star, named after the scientist who first proposed such a construct, Freeman Dyson.

Dyson spheres would be constructed so that their inhabitants lived on the inside of the shell. Most of the energy emitted by suns is lost in space, only a minute fraction of our own sun's light falling on Earth. But with a Dyson sphere, all the available light — and hence energy — would be trapped and harnessed. The sphere would have to spin in order to produce gravity in an equatorial zone, though any civilization sufficiently advanced to build one may also be able to generate artificial gravity. They would also need to find ways of overcoming the inertial stresses which would threaten to tear the shell apart.

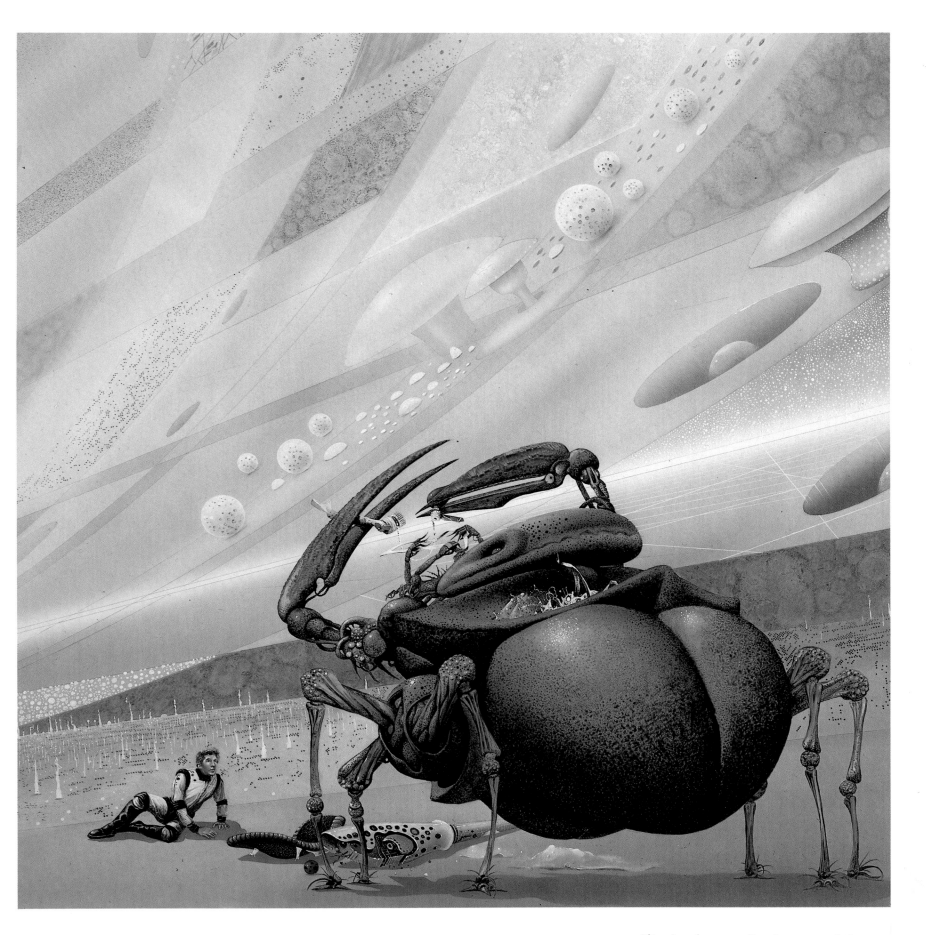

Alien Landscapes – Rendezvous with Rama 2
(Mechanical Beetle) 1979, Pierrot Publishing

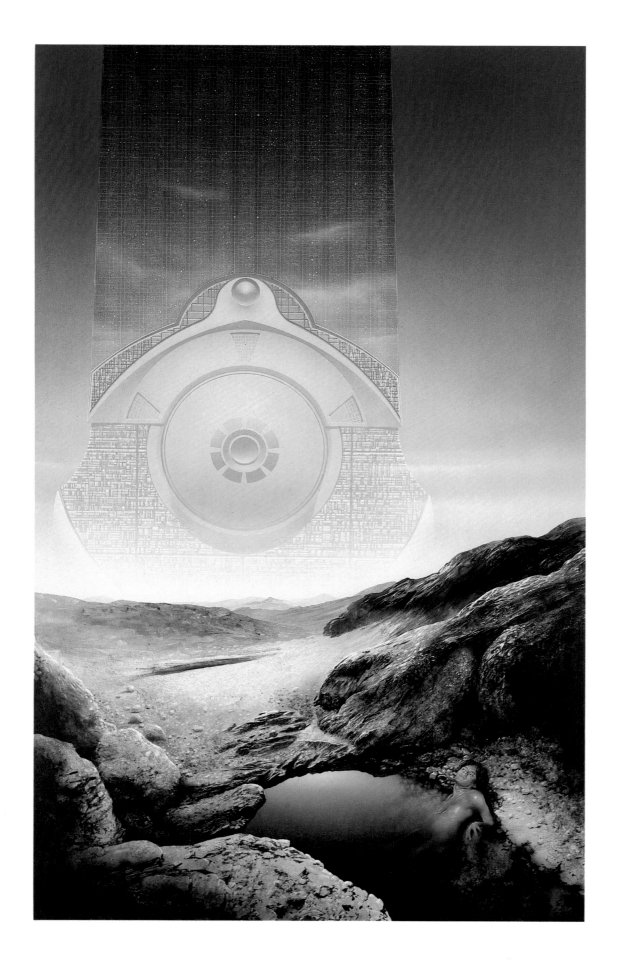

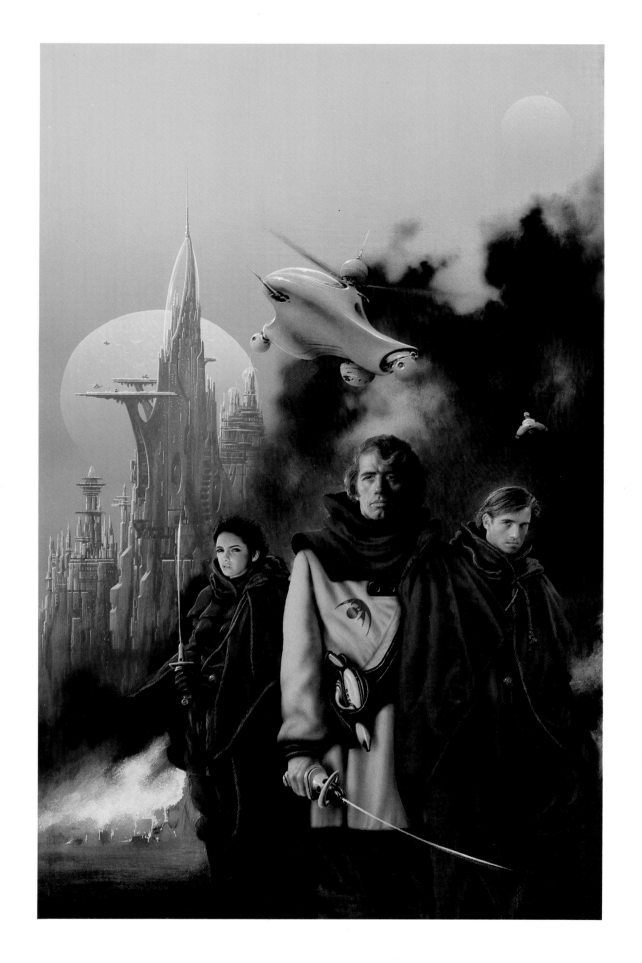

A Quiet of Stone 1983, Bantam Books, New York

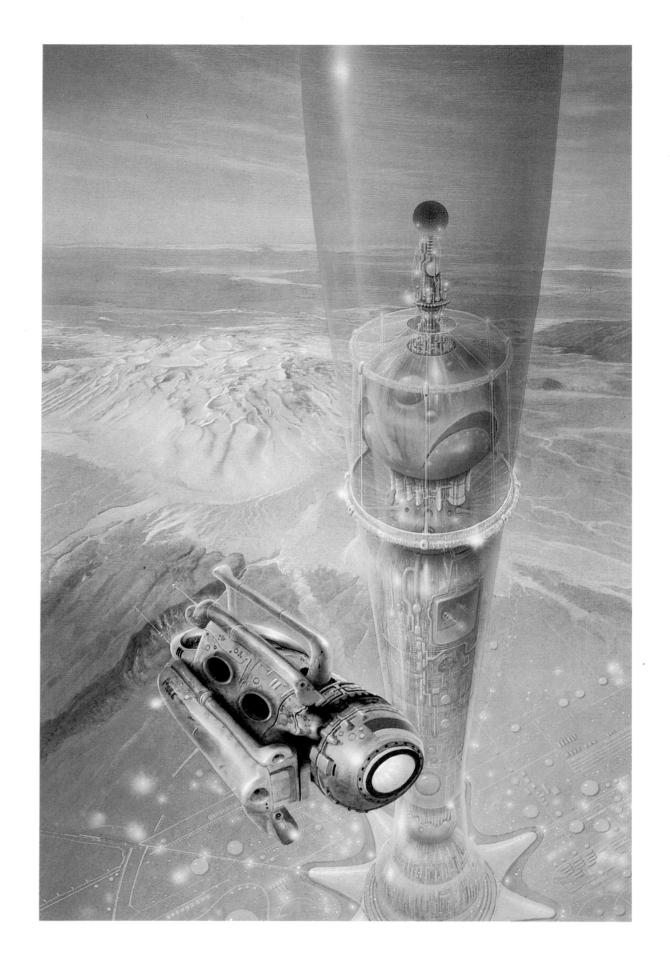

The Tower of Glass 1983, Bantam Books, New York 104

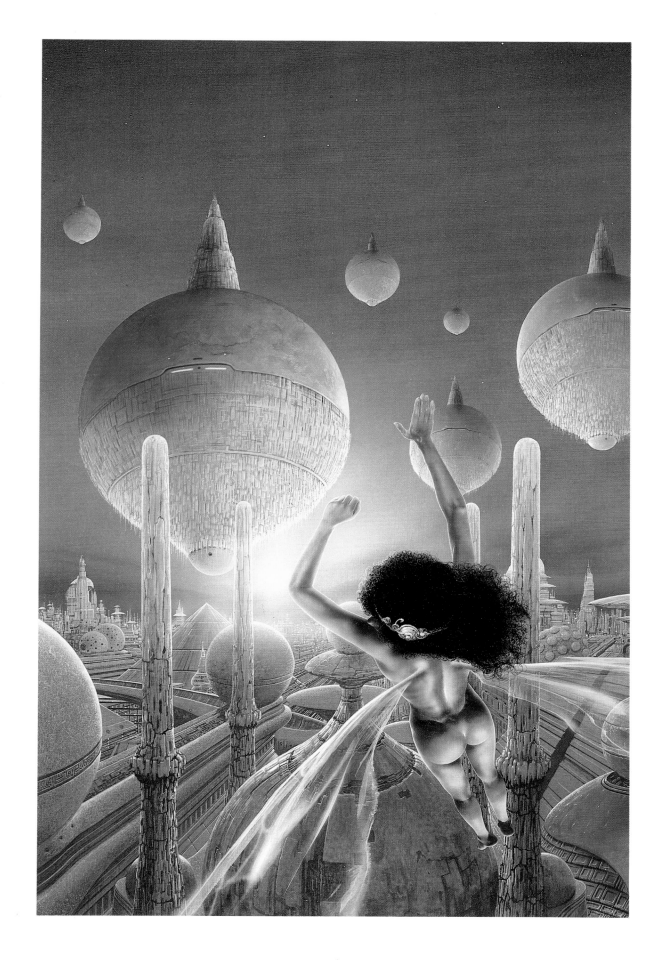

Nightwings 1983, Avon Books, New York

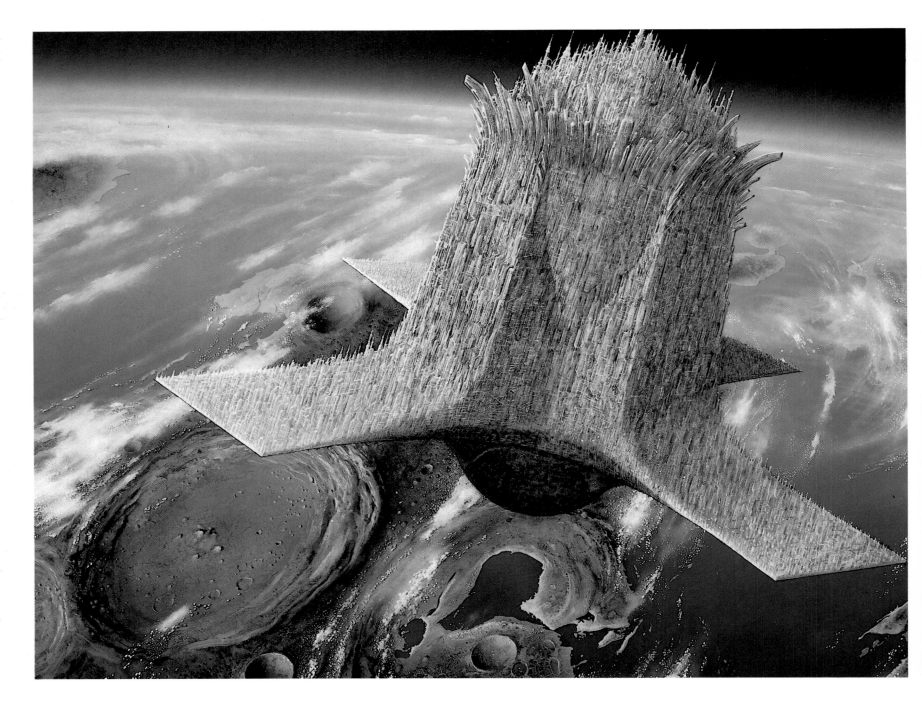

Tour of the Universe – Refuge 1980, Pierrot Publishing

Aside from its energy potential, the obvious advantage of building a Dyson sphere is that it would create an enormous habitable area capable of supporting an equally enormous population. A sphere with the diameter of the Earth's orbit around the Sun would have roughly a thousand million times more room than the Earth's surface.

Dyson spheres could only be built by civilizations far more advanced than our own, and they would perhaps be the ultimate in artificial habitats. Artificial worlds of more ornate design create their own visual splendour, as with the mothership in the film *Close Encounters of the Third Kind*,

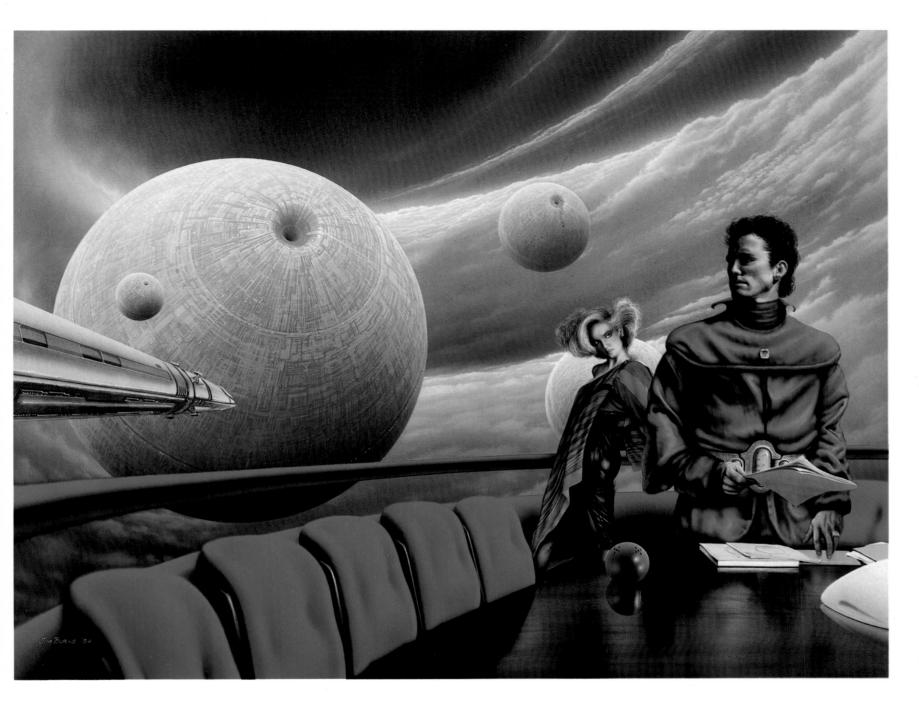

Bio of a Space Tyrant 3 – Politician 1984, Avon Books, New York

or Jim Burns's *Refuge*, both of which in their different ways recall elaborate chandeliers.

For Burns the personal challenge in depicting artificial worlds lies in making them look like worlds rather than just large spacecraft. "The most successful method, I think, is by suggesting a mass of tiny details which has the effect of endowing scale on a construction. Mediaeval cathedrals have always seemed to me rather larger than their physical measurements suggest. I think it's the plastering of the facades with tiny decorative motifs, statues, nooks and crannies, that does it. So in a piece like *Refuge* I used a similar device. It could so easily look like a

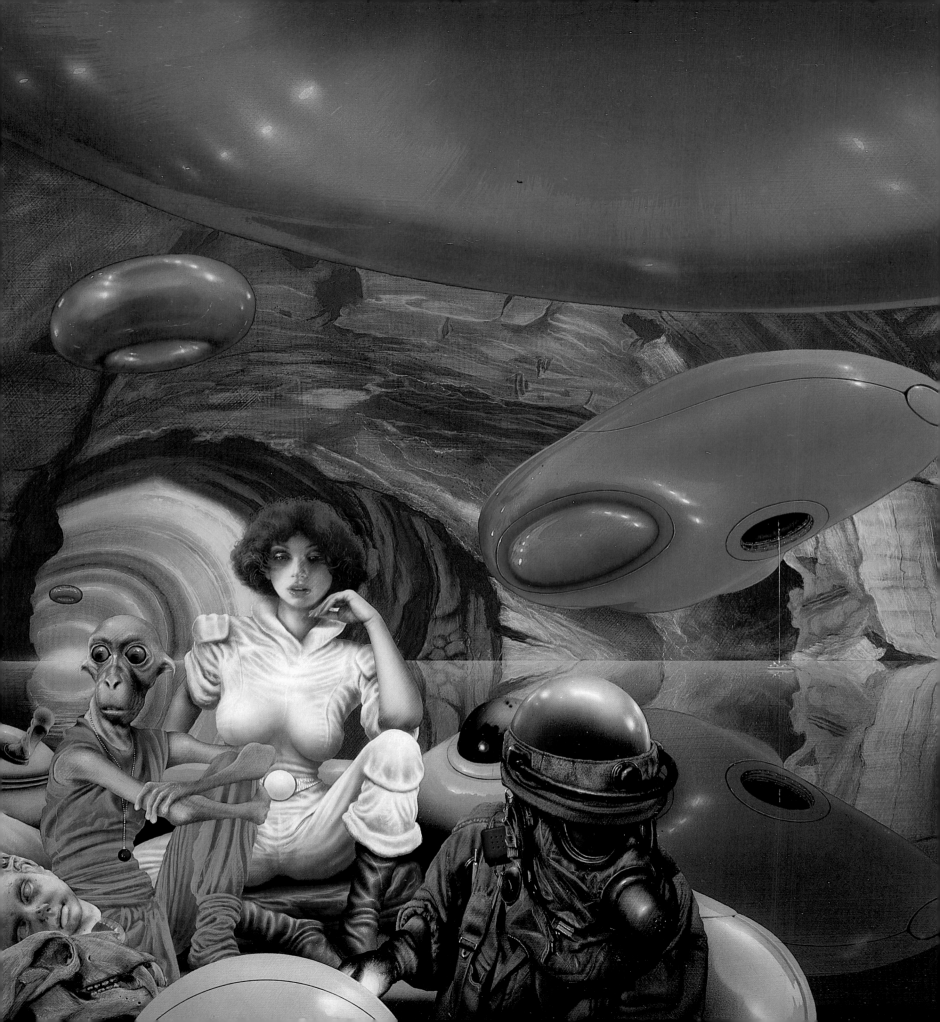

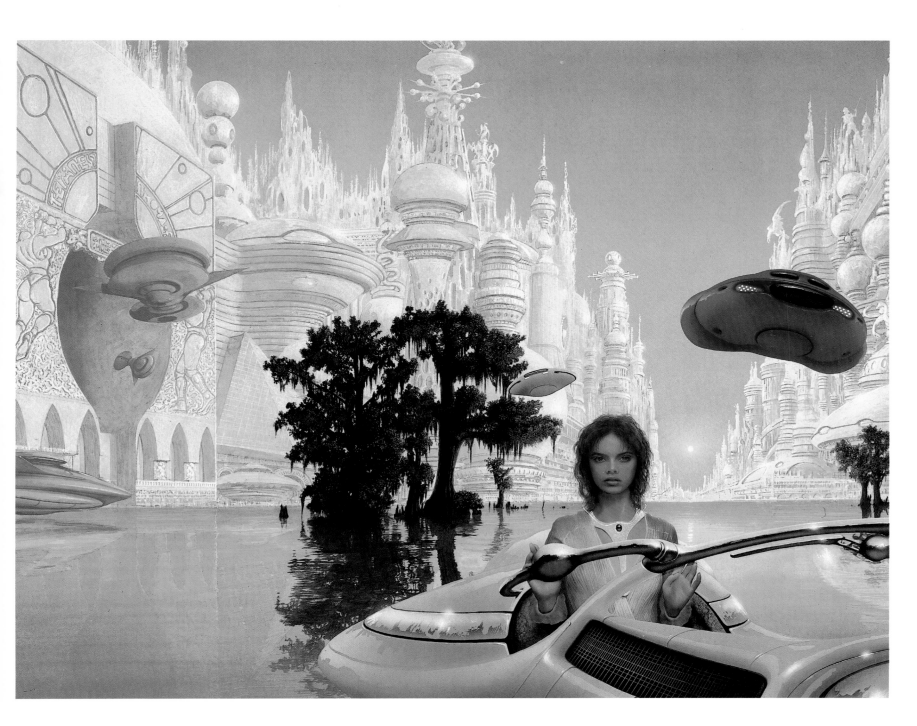

The Majipoor Chronicles 1982, Gollancz

spacecraft in orbit around an Earth-type planet, but it somehow convinces that it's something else — probably a sort of anti-gravity city."

Whether detailed or not, the favoured shape for artificial worlds in today's science-fiction tends to be spherical, a shape already enshrined in modern mytho-logy by the Deathstar in the film *Star Wars*. There's something psychologically appealing about a globe-shaped world whose inhabitants dwell on the inside rather than the surface of a sphere — it's a way of really turning the tables on nature.

Anthology cover 1985

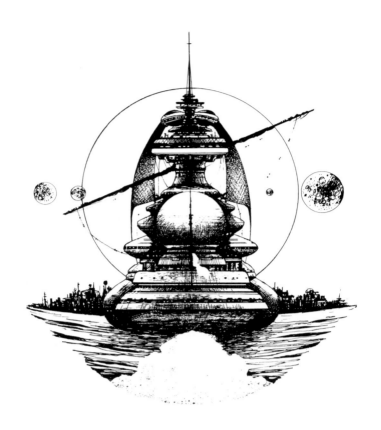

THE FARTHEST SHORE

In the end, given the means, we will travel to other star-systems. There we will doubtless find new planets, many of which will be hostile to human beings. We will search for Earth-like worlds, with a breathable atmosphere, a bearable gravity, plenty of water and temperatures no colder than the Arctic and no hotter than the Sahara.

Such planets will probably be in short supply. Perhaps only a minority of stars support planetary systems in the first place, over half of them being double or multiple star-systems which may not provide stable conditions for planetary formation. And even where planets exist, they are unlikely to be Earth-like worlds. Our own Solar System has nine planets, four of which are gas-giants wrapped in dense, toxic atmospheres. Two more are far too hot for human life, while a third is far too cold. This leaves only the Earth and Mars. But Mars has a thin atmosphere with no oxygen and little surface-water. Life there, even in its crudest form, appears to be absent.

It's likely that we'll find similar hostile conditions predominating on planets orbiting other suns. And even if

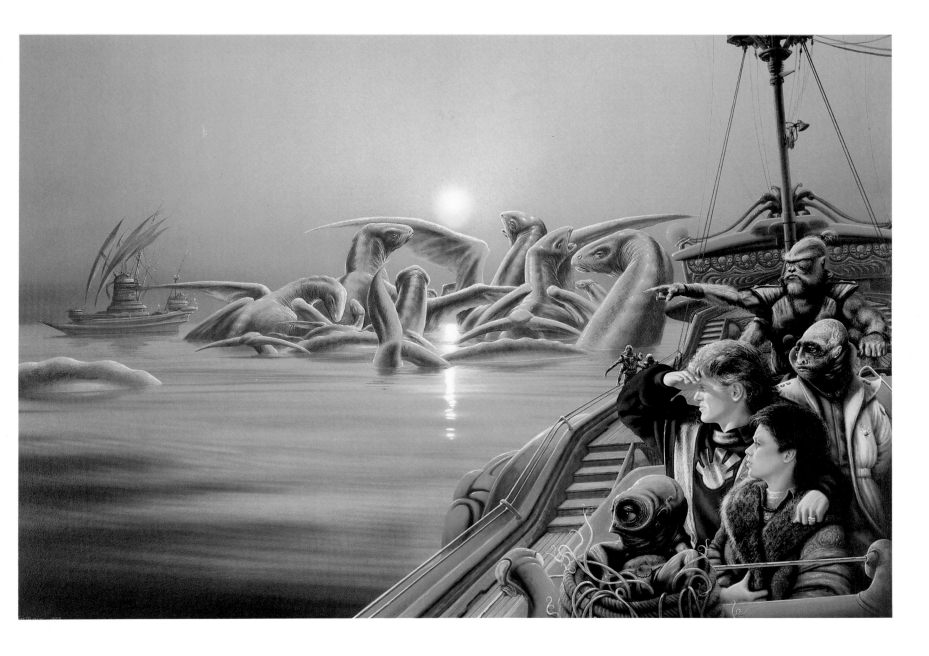

Valentine Pontifex 1984, Gollancz

we do find Earth-like worlds, they may not be geologically stable, or they may allow too much hard radiation to penetrate to the planet's surface to support life. Or we might find them in the grip of an Ice Age which on Earth lasts far longer than one of the warmer interglacial periods which we are currently inhabiting on Earth. All these factors may combine to make the search for colonizable worlds like looking for a needle in a galactic haystack.

Of course by then the human race may be sufficiently advanced technologically to be able to "terraform" planets — convert them into worlds like Earth. Our close neighbour Venus has often been considered as a candidate for such a process. It's about the same size as Earth, but at present its dense atmosphere keeps the surface temperature far too high for life as we know it. A popular idea is to release algae into its atmosphere which would break down the carbon dioxide largely responsible for trapping the sun's heat. Breathable oxygen would then be liberated, and the temperature of the planet

would gradually fall to a point where human beings could tolerate it.

This, in very broad outline, would be a way of terraforming Venus. With planets that are too cold, like Mars, solar mirrors could be used to concentrate the Sun's heat and hence warm up the planet. Frozen carbon dioxide would be released into the air, and once again algae could be used to convert this into oxygen. Other planets present greater difficulties. Gas-giants such as Jupiter are so large, with atmospheres like chemical soups, that they're probably not suitable for terraforming, although the larger moons orbiting them such as Titan may have potential.

The reverse option to terraforming would be "pantropy" — the redesigning of human bodies to fit planetary environments different from Earth's. On cold worlds, people with fur or leather-like skins would be better equipped to survive; on planets with murky atmospheres human eyes which could see shorter wavelengths than visible light might be produced through genetic engineering; on low-gravity worlds people might have bat-like wings so that they could actually glide from place to place. And so on.

Science-fiction writers enjoy playing with such possibilities, and future advances in genetic engineering could well make specific modifications to human bodies practicable. They may never occur, however, for we would effectively be creating a species of human so different from us that they would seem like aliens. And real aliens may already be out there, waiting for us.

Some scientists believe that life on Earth is the result of a million-to-one chance and that we are therefore alone in the universe. Others take the view that similar forms of evolution on other worlds could have produced intelligent species which may or may not resemble human beings. Science-fiction has always taken it for granted that there

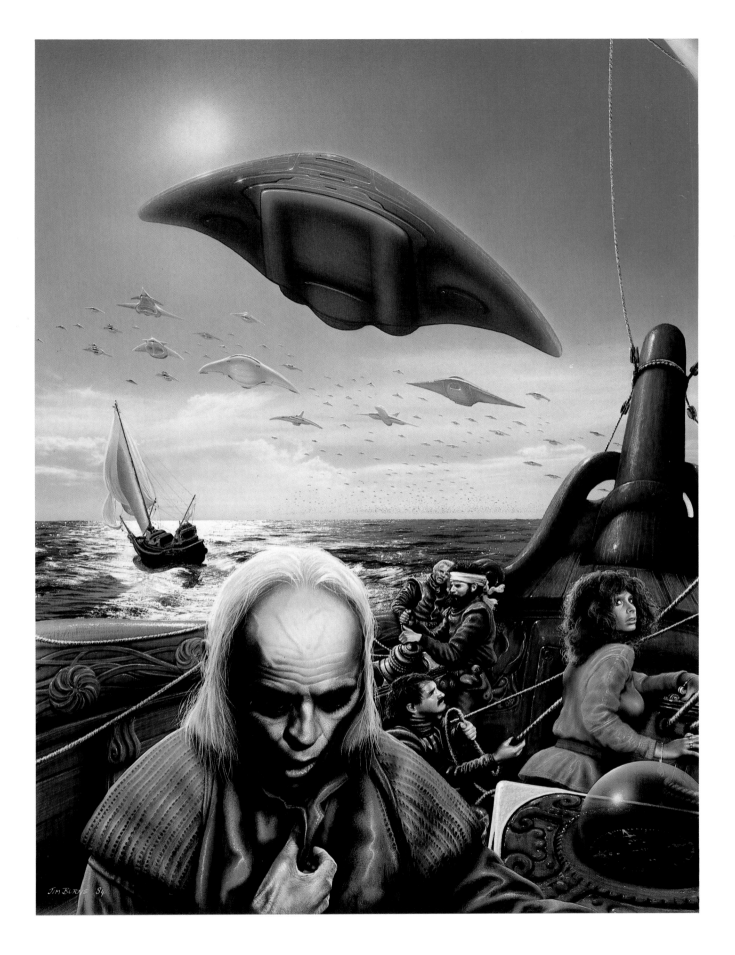

Saraband of Lost Time 1984, Avon Books, New York

Dan Dare (1) 1980

will be hosts of habitable worlds out there in space, with alien species aplenty to snap at the heels of intrepid human explorers.

Humanoid aliens were discussed in Chapter 6, but there is no special reason to suppose that intelligent life will resemble us. A favourite device of science-fiction writers is to imagine aliens evolved from cat- or dog-like creatures, while whales and dolphins have also proved particularly popular because these are creatures on Earth which may be possessed of intelligence and some form of social order. We use the familiar to create the strange.

Many other kinds of creatures have formed the prototypes for aliens, incuding ant- and bee-type species whose individuals are often portrayed as being just a small part of a larger intelligence, the hive-mind. A related idea is the concept of the Gestalt being, a super-mentality holding the wisdom and experience of a whole race. At the other extreme, the gruesome creature in the film *Alien* which grows inside human bodies is based on the life-cycle of the ichneumon fly, whose grubs eat their way out of the bodies of butterfly caterpillars.

Life on Earth is founded on the fact that carbon atoms may be chemically linked into long and complex molecules which are the building blocks of all living things. Life-

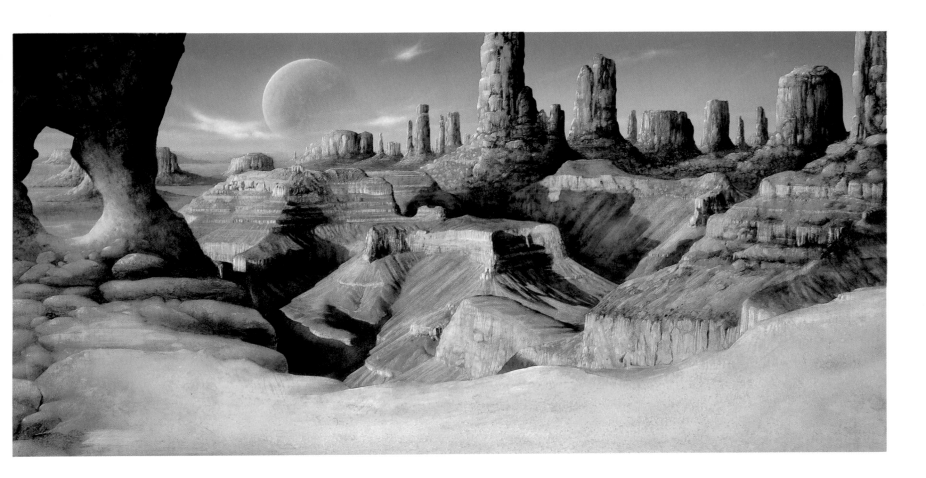

Dan Dare (2) 1980

forms have also been postulated which are based on silicon, an element chemically similar to carbon. Silicon is a major constituent of most rocks, and silicon beings might be stone-like or crystalline. But silicon lacks carbon's capacity for combining with itself into long chains, and it's unlikely that an alien biochemistry could be derived from it.

Even stranger lifeforms have, however, been imagined in fiction. The astronomer Fred Hoyle described in one novel a completely inorganic intelligence in the form of a cloud of interstellar gases which has formed in space and which survives by surrounding stars to warm itself.

Other writers have imagined that even stars themselves could be sentient beings.

The Polish writer Stanislaw Lem has created some impressively inscrutable alien species such as a living ocean or a range of bizarre phenomenon encountered by a team of humans on another planet which cannot be understood but which must be the products of some form of intelligent life. Here we are far away from the idea of the alien who looks and behaves like a human being except for his green skin or his forked tongue. True aliens may be so different from us that we can never hope to understand them.

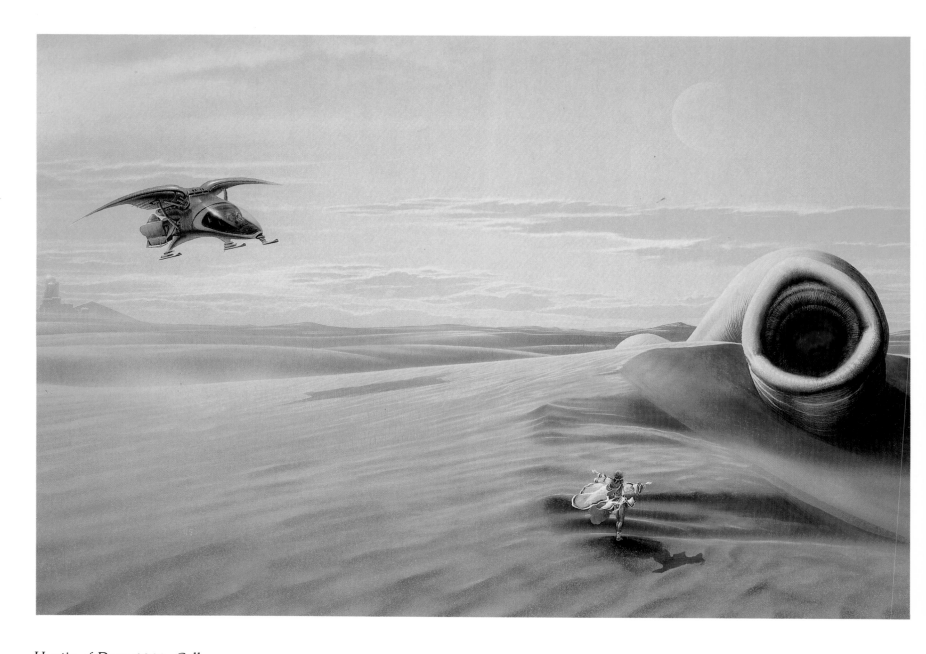

Heretics of Dune 1983, Gollancz

Most science-fiction, though, requires that there be some form of communication between human and alien, no matter how strange the latter may appear. Similarly, alien worlds are mostly assumed to be environmentally friendly towards humans in a broad sense so that they don't get in the way of the action. No doubt this also reflects a certain wish-fulfillment on our part — we hope that the universe out there will prove to be accommodating to us, even if we have to fight for our place in it.

Alien planets have always been happy hunting grounds for s-f writers and artists ever since the advent of the pulps. Most of the early stories produced were effectively planetary romances where the aliens were monster-like or crudely villainous and were therefore to be conquered by humans. And conquered they almost always were, nothing being allowed to stand in the way of our outward march through the cosmos.

The illustrations accompanying such stories rarely showed much landscape beyond what was essential. The emphasis was instead on skulking aliens and noble-

The Amtrak Wars 1983, Sphere Books

browed human explorers. The aliens resembled insects or reptiles, or they would look very much like human beings except for their pointed ears, bulging eyes, bald heads, and skins all colours of the rainbow. The alien worlds were like African jungles with lost temples, or medieval lands with living gargoyles, or the Wild West with laser-rifles for Winchesters and marauding man-apes for Red Indians.

Planetary romances tended to fall out of favour in the late 1950s as science ficiton became more literate and self-conscious. Illustrations became more astronomical or technical, concerned with humans and their artifacts as opposed to other worlds. But in the last ten years or so, artists have rediscovered the planetary landscape, and they're finally beginning to do it full justice. As with the starship, they've brought it alive in ways which no writer has ever managed, populating it with quirky structures, exotic flora and fauna, but above all finally managing to convey the broad expanses of land and sea which actually hint at a whole world.

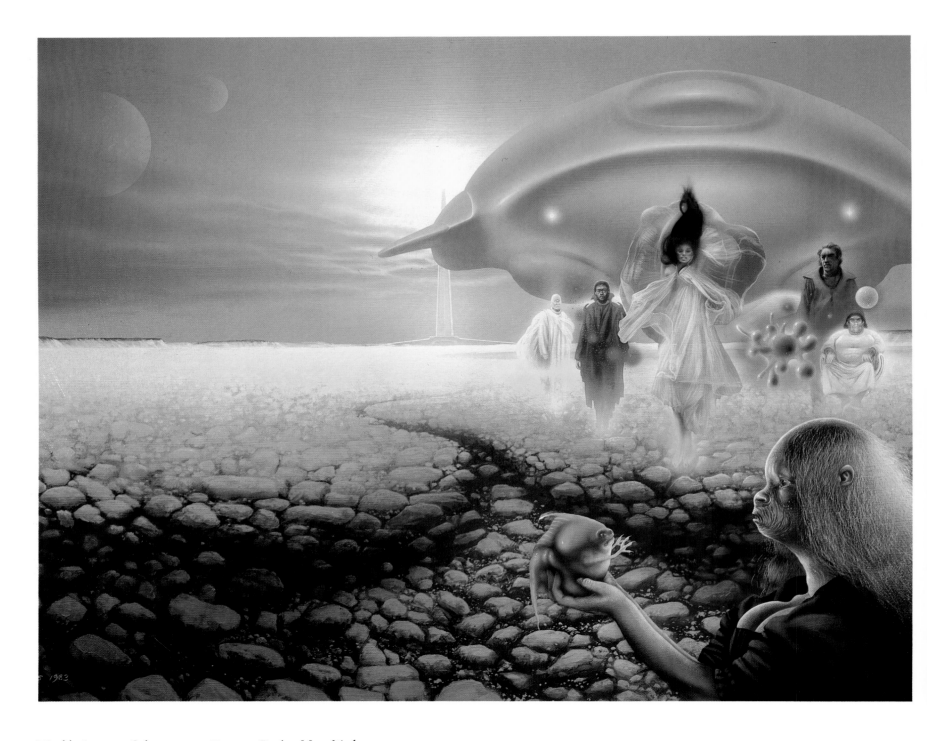

World of 1000 Colors 1983, Bantam Books, New York

This sense of panorama is found in many of Jim Burns's best illustrations of alien planets. His pictures often show wide horizons in which stretches of ocean or mountain ranges are backdropped by skies filled with clouds or moons. Many of them are wrap-around covers which express the extra freedom which the greater space allows to go beyond the strictures of the brief. Usually in Jim Burns's case this means the freedom to paint expanses of sky, sea and land which don't have to be filled up with figures and vehicles. As a result, they are far more effective as landscapes.

"It's a bit of evolutionary variety that I want to suggest

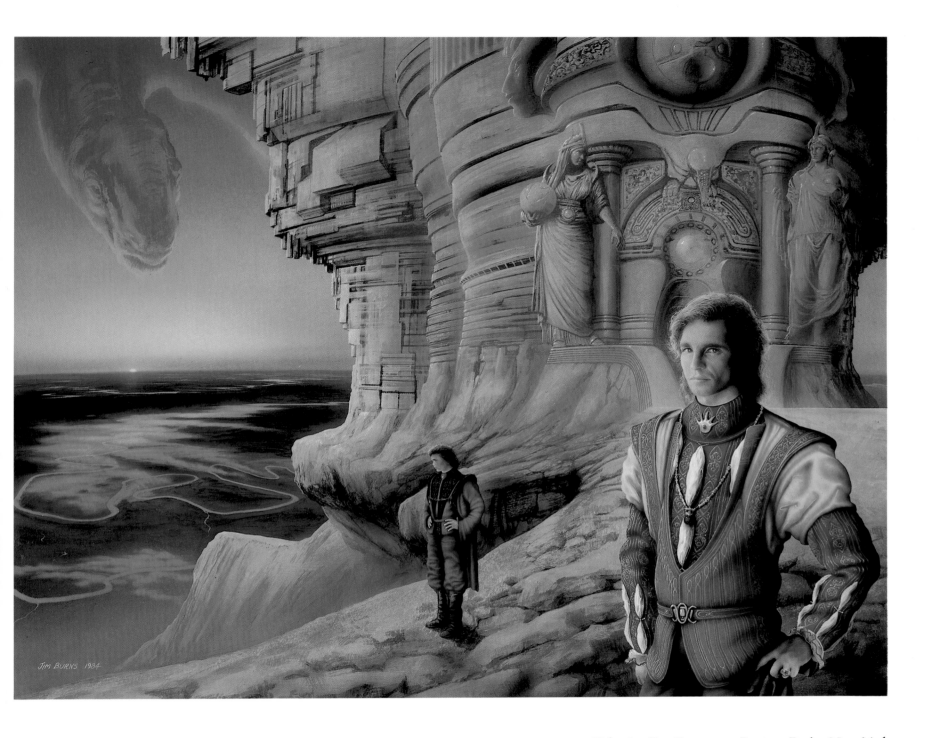

Valentine Pontifex 1984, Bantam Books, New York

in these images. What I also hope surfaces, particularly in some of the more ambitious panoramic landscapes, is a hint of something joyous or celebratory in the unfolding pageant." This is certainly seen in many of the pictures. They speak of exotic worlds in which humanity has nevertheless found a place. People fraternize with aliens of many kinds, and Burns is good at designing his pictures so that even creatures with tendrils and amphibian faces or entities like complex balls of light can be perceived as intelligent beings, communing with the human race. This speaks directly to one of science-fiction's fondest wishes, the urge to join a galactic club of sentient creatures, to be

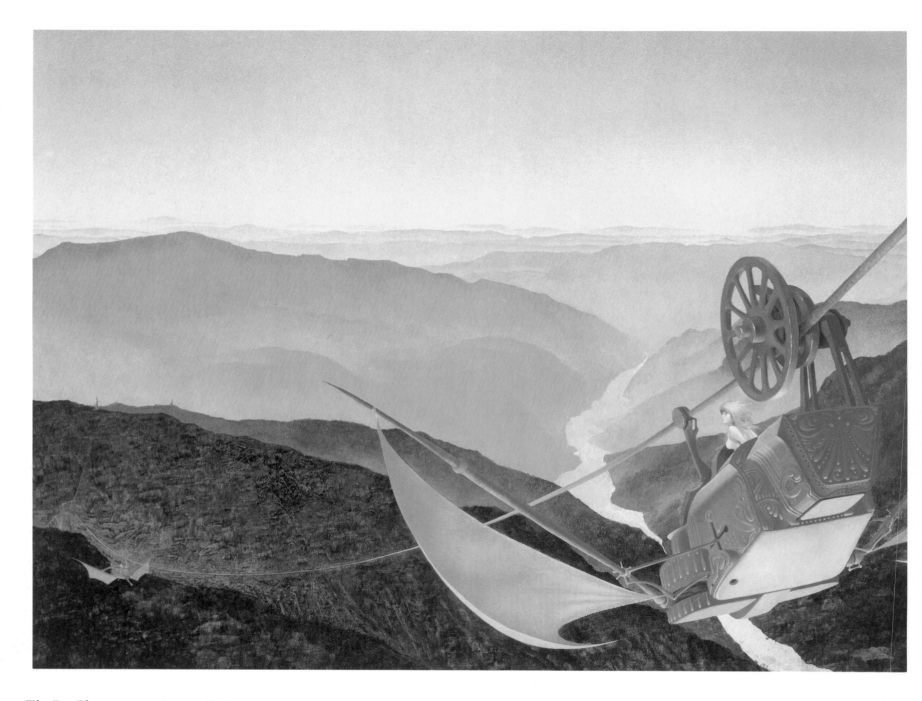

The Big Planet 1977, Coronet Books

accepted wherever we might go in the universe. And here, under distant suns, the human race is seen as perfectly at home.

"I want to suggest materials which are not wood or metal or plastic or anything known to us," says Burns. "To perhaps one day paint a picture — convincingly — in which a great neo-baroque, encrusted vessel of beaten gold or sculpted jade ploughs through metal or gaseous oceans while overlording the view are binary or triple suns and ruined pock-marked moons or anti-gravity cities, the whole scene being coloured in the glow of a spectrum which at least *suggests* those wavelengths beyond

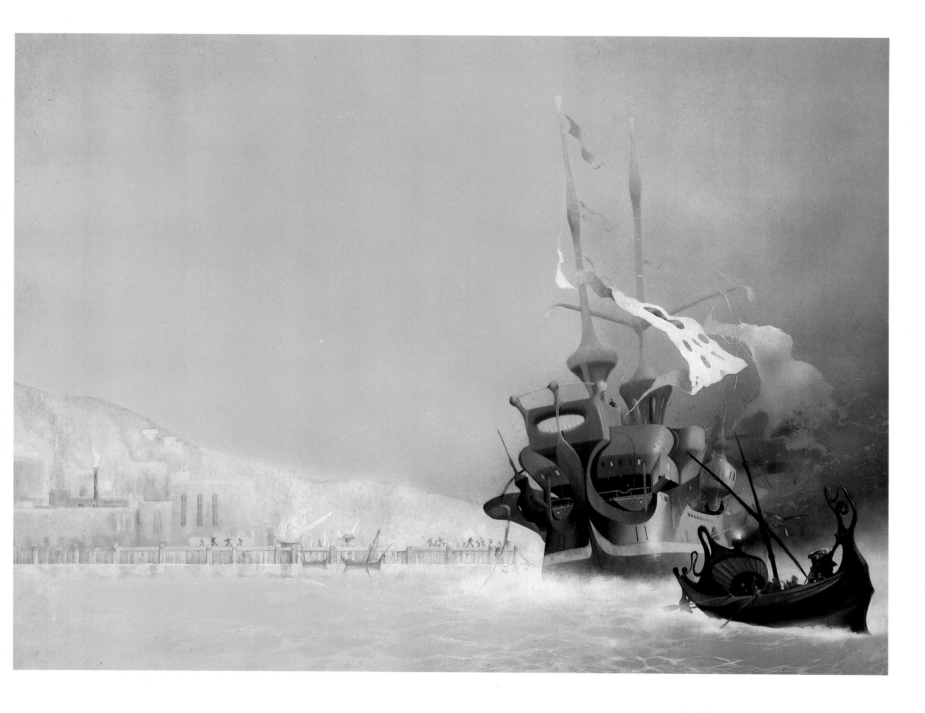

Showboat World 1977, Coronet Books

our poor human senses. I can see all these things in my mind's eye. If only I could translate into paint the images my imagination conjures up."

Science-fiction art comes in many guises, but it is, above all, a positive and affirmative art which constantly celebrates the grandeur of the universe. Sometimes its visions can be dauntingly technical or neglectful of the more intimate aspects of human life. But at least it shows *homo sapiens* as a striving, inventive species, abrim with potentials. In these uncertain and sceptical times, this is surely something to be grateful for.

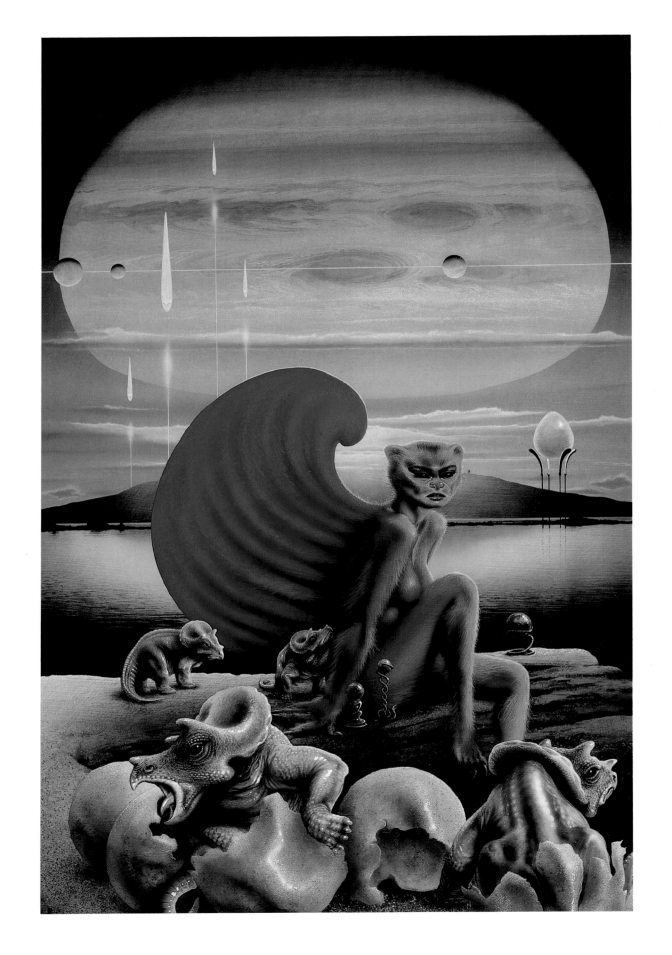

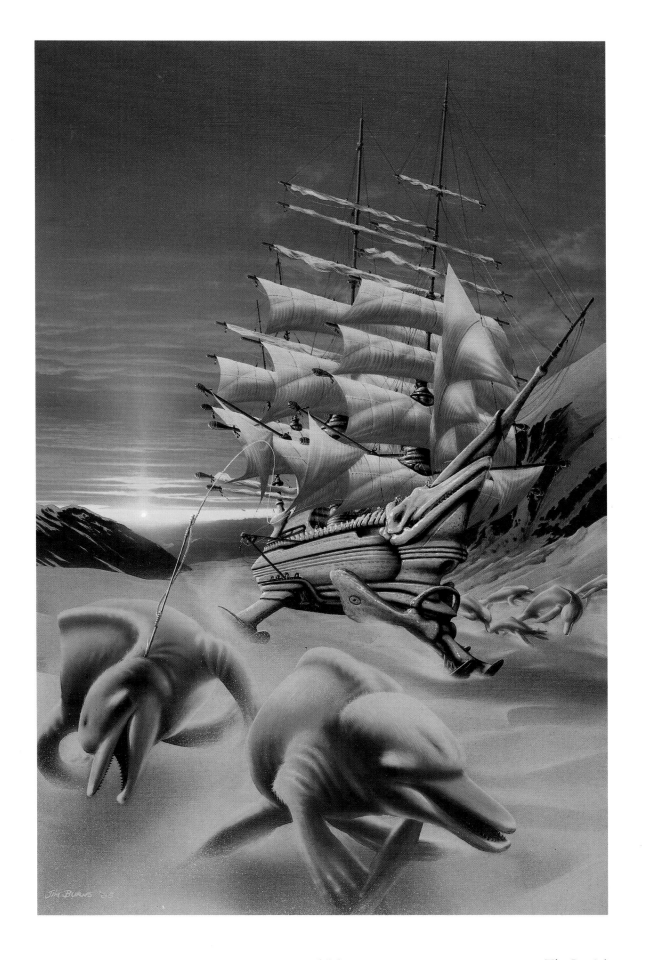

The Ice Schooner 1985, Panther Books

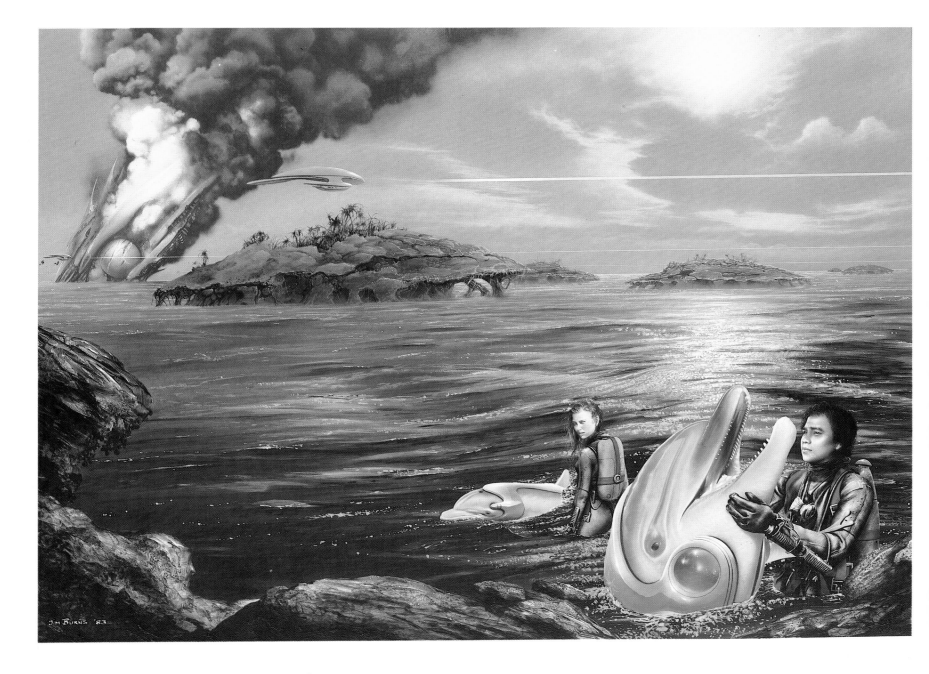

Startide Rising 1983, Bantam Books, New York

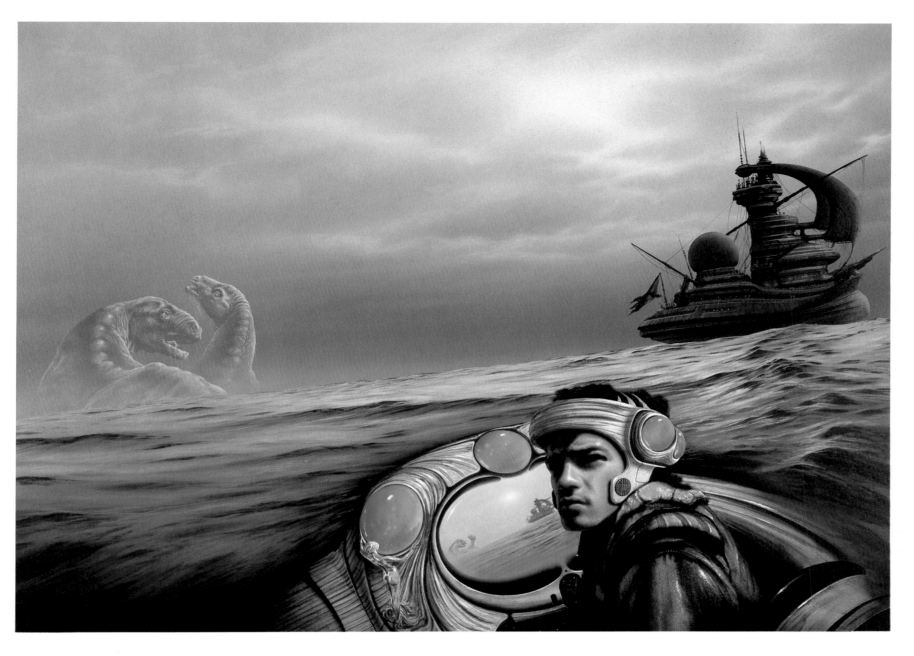

The Majipoor Chronicles 1982, Bantam Books, New York